IMAGES
of Rail

HARTFORD TROLLEYS

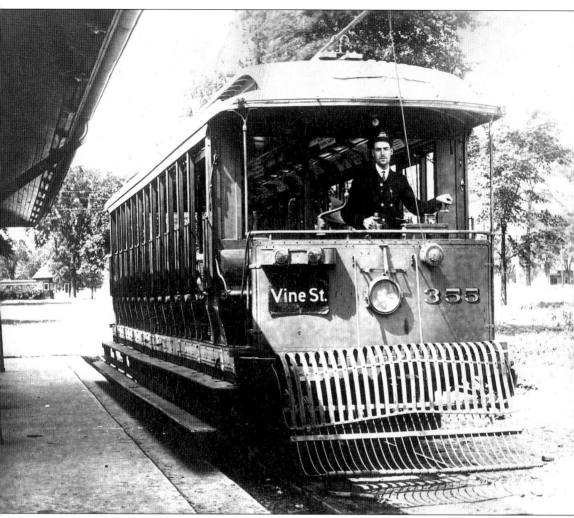

Open cars such as No. 355, shown here at the entrance to Keney Park on Hartford's Vine Street line, were used in the warm summer months. Unfortunately, the open car was eliminated when companies could no longer afford to have cars that were used only part of the year and required precious storage space the rest of the year. Car manufacturers began building "semi-convertible" cars with large windows that folded up into the car body, providing an airiness akin to open cars. Car No. 355 was built in Worcester, Massachusetts, by the Osgood Bradley Company in 1910.

IMAGES
of Rail

HARTFORD TROLLEYS

Connecticut Motor Coach Museum

ARCADIA

Copyright © 2004 by Connecticut Motor Coach Museum
ISBN 0-7385-3600-8

First published 2004

Published by Arcadia Publishing
Charleston SC, Chicago IL, Portsmouth NH, San Francisco CA

Printed in Great Britain

Library of Congress Catalog Card Number: 2004103398

For all general information, contact Arcadia Publishing:
Telephone 843-853-2070
Fax 843-853-0044
E-mail sales@arcadiapublishing.com
For customer service and orders:
Toll-free 1-888-313-2665

Visit us on the Internet at www.arcadiapublishing.com

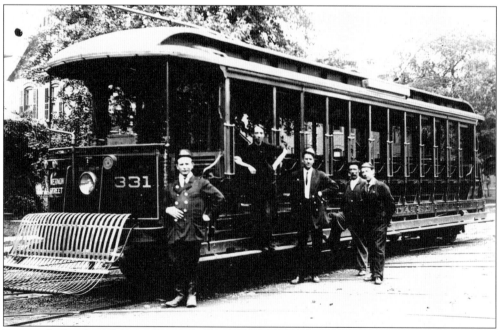

During the heyday of the trolley, before the advent of air conditioning, riding on an open car was definitely a pleasant experience. The Connecticut Company had one of the largest fleets of open cars in the country and was one of the last major transit companies to use open cars in public service. Car No. 331, shown here in front of the Vernon Street car barn, was purchased from the Wason Manufacturing Company in 1907 by the Consolidated Railway. When it was delivered, the car was painted maroon with gold trim. By 1915, the car had been repainted in the traditional Connecticut Company paint scheme (chrome yellow with red and white trim) and renumbered 1108.

CONTENTS

PREFACE

This book is dedicated to William A. Mertens, who was an avid trolley and motor coach enthusiast and a Connecticut Company motor coach operator. Also an operator at the Connecticut Trolley Museum in East Windsor, William trained most of the other streetcar operators there during the 1950s and 1960s. William and Horace D. Bromley, who provided all the photographs shown in this book, were coworkers at the Connecticut Company for many years. William retired from Connecticut Transit in 1985 as manager of the Schedule Department.

Proceeds from this book will go directly to the Connecticut Motor Coach Museum to assist in the maintenance of its collection of historic motor coaches, many of which were obtained through William Mertens's efforts.

—Alan J. Walker
President, Connecticut Motor Coach Museum
58 North Road, East Windsor, CT 06088

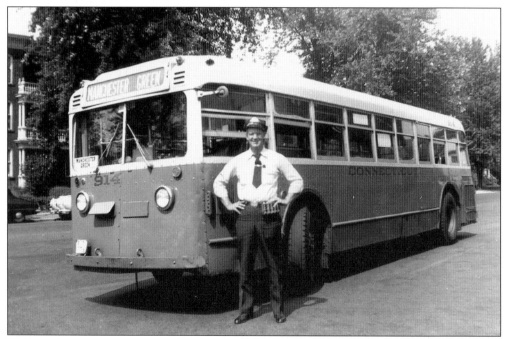

William A. Mertens appears in this 1945 scene with Connecticut Company Motor Coach No. 914, a Yellow Coach Model 731. This photograph was taken at the same site as Car No. 331 on page 4.

INTRODUCTION

Public transportation in Hartford began in 1859, when the Hartford & Wethersfield Horse Railroad was granted a charter by the General Assembly. This was one of the first public transit companies in the United States. Hartford joined Boston, New York, and Chicago in providing rapid transit to its inhabitants.

Horse cars first began to carry passengers on March 31, 1863, with a run from the Old State House on Main Street to the horse-car stables on Wethersfield Avenue. By June, the line was operating from Spring Grove Cemetery on North Main Street to Wethersfield Green in the neighboring town of Wethersfield. By September, another line was open on Asylum Street and ran from Woodland Street down State Street to the steamboat docks.

The system was not extended again until 1872, when the Farmington Avenue line started operation. Other lines soon followed, such as the Retreat Avenue line, constructed in 1881. The 1880s saw the company expand tremendously as lines were constructed on Lafayette Street in 1882, Park Street in 1882, Albany Avenue in 1883, Capitol Avenue in 1889, and out to the suburb of West Hartford via Farmington Avenue in 1889. In 1890, horse-car service east of the river began with a line from State Street in Hartford to the north end of East Hartford, initially using a covered bridge over the Connecticut River that had been built in 1818.

By 1888, the horse-car company was looking for an alternate energy source. Electricity allowed longer routes at a much more reasonable cost. The cost of feeding, housing, and caring for a large number of horses, as well as the cars they pulled, was a formidable expense. The Connecticut cities of Derby and Meriden already had electric cars running. The Hartford & Wethersfield Horse Railroad decided to do the same. In 1888, the three-mile stretch from the Wethersfield Avenue stables to Wethersfield Green was electrified. On September 21, 1888, the first trip was made, using horse cars fitted with electric motors. Power for the line was furnished by the Hartford Light & Power Company.

In 1893, the decision was made to change the name of the Hartford & Wethersfield Horse Railroad to the Hartford Street Railway. The principal stockholder was the City of Hartford. A new charter was issued to the Hartford Street Railway by the General Assembly. This charter included rights to build lines north to Windsor and east to South Windsor, as well as additional lines to Wethersfield, Glastonbury, and East Hartford.

By 1894, all the former horse car lines had been converted to electric operation. This change necessitated the equipment—all of the horse cars—to be converted to operate on electricity. This was achieved by the addition of electrically powered motors and controllers. The two horse stables, at Wethersfield Avenue and Vernon Street, were converted into streetcar barns.

During the late 1890s, lines were built to provide all the suburbs of Hartford with trolley service. Lines were built to New Britain via Newington, South Glastonbury, the village of East Windsor Hill, the Elmwood section of West Hartford, and the Burnside section of East Hartford. Lines to Manchester and Rockville were built by the Hartford, Manchester, and Rockville Tramway Company starting in 1894. This construction provided thousands of additional people with access to Hartford and its businesses.

In 1905, the Consolidated Railway, a subsidiary of the New York, New Haven, and Hartford Railroad, purchased the Hartford Street Railway. In addition, the company purchased the Hartford, Manchester, and Rockville Tramway Company in 1906. In 1907, the Consolidated was renamed by the railroad and became the Connecticut Company to reflect the area it served.

Just as the Hartford Street Railway had done in the late 1890s, the Connecticut Company implemented an expansion program, starting in 1908 with the opening of the line from East Hartford to Rockville and Stafford Springs. Other lines that opened in 1908 were the Franklin Avenue line and branches off the Hartford to Manchester line—Manchester Green in the eastern section of Manchester and Depot Square in the northern section. In 1909, the Franklin Avenue line was extended to Griswoldville and Rocky Hill and eventually to Middletown. A line was also built to the farming community of Bloomfield Center. In 1910, the Connecticut Company purchased the Unionville line from the Farmington Street Railway, which had previously been independent.

With all the acquisitions made by the Connecticut Company, various color and numbering systems developed for the cars. By 1915, all the equipment acquired from the former companies had been integrated into the Connecticut Company numbering system and paint schemes.

In 1921, the first motor-coach operation began with a line running from Union Station to the junction of Main Street and Albany Avenue called "the Tunnel." That same year saw the first streetcar line abandonment: the Lafayette Street line from Capitol Avenue to Park Street. Later in 1921, the Asylum Avenue line was also converted to motor-coach operation. The Elizabeth Park line was converted to motor-coach operation in 1926. Between 1926 and 1933, the following lines were abandoned: the Rockville to Stafford Springs, Sisson Avenue, and Glastonbury Center to South Glastonbury in 1928; Manchester Green and Depot Square in 1929; Rocky Hill to Middletown and Windsor Center to Rainbow in 1930; Rockville to Hartford in 1931; Bloomfield Center in 1931; East Windsor Hill in 1932; and Unionville in 1933. Many of these lines were converted to bus routes at that time. By 1935, the streetcar system had been confined mainly to the Hartford city limits. The only lines that continued to operate outside of the city were those to Glastonbury Center, Manchester Center, Windsor Center, Wethersfield Green, New Britain, and Elmwood.

In 1934, the Connecticut Company was losing almost $2 million a year statewide. The company could not continue to operate without the help of its parent company, the New Haven Railroad. Unfortunately, the New Haven Railroad declared bankruptcy on October 24, 1935. Within a week of that time, the Connecticut Company itself was forced to file bankruptcy.

By 1940, the Hartford City Council wanted all streetcar service discontinued in the city. With the steadily increasing numbers of cars and trucks on the streets in Hartford, streetcar operations became increasingly dangerous and cumbersome. On December 23, 1940, the city council empowered Mayor Spellacy to sign an agreement with the Connecticut Company. Under the terms of this agreement, all streetcar service would be replaced by motor-coach service within one year. In turn, the city would agree to forego the road maintenance fees included in the Connecticut Company's charter. The fees totaled about $20,000 and were paid to the city of Hartford yearly. As the parent of the Connecticut Company, the New Haven Railroad had to apply to the court for permission to purchase the motor coaches that would replace the trolleys in Hartford. On January 6, 1941, the court gave the New Haven Railroad permission to spend $1 million for 100 motor coaches and another $280,000 to provide additional garage facilities at the Vernon Street car barn. The other issue with abandoning the streetcars in Hartford was the Commerce Street power station where electrical current—purchased from the Hartford Electric Light Company—was converted from alternating current (AC) to direct current (DC). After the 1938 flood, the Army Corps of Engineers embarked upon a flood-control project, which included building dikes to protect the city. The location of the dikes necessitated the tearing down of the power station. The city would be required to erect a new powerhouse elsewhere, at an estimated cost of $32,000, if trolley service were to remain after 1941.

Starting in May 1941, the lines were converted as the motor coaches arrived from General Motors. The first lines to be converted were the Elmwood, Wethersfield, and Albany Avenue lines on May 18. Finally, on July 27, the Barbour Street, Charter Oak Avenue, North Main Street, and Park Street lines were converted to bus. When Car No. 929 returned to the Wethersfield Avenue car barn at 4:30 a.m. on July 28, trolley operation on the streets of Hartford was over. Seventy-eight years had gone by between the first horse-car run and No. 929's last trip. The East Hartford–Glastonbury line continued to operate for freight service, using two express cars that had been converted to diesel engines. This line, too, stopped running in 1967.

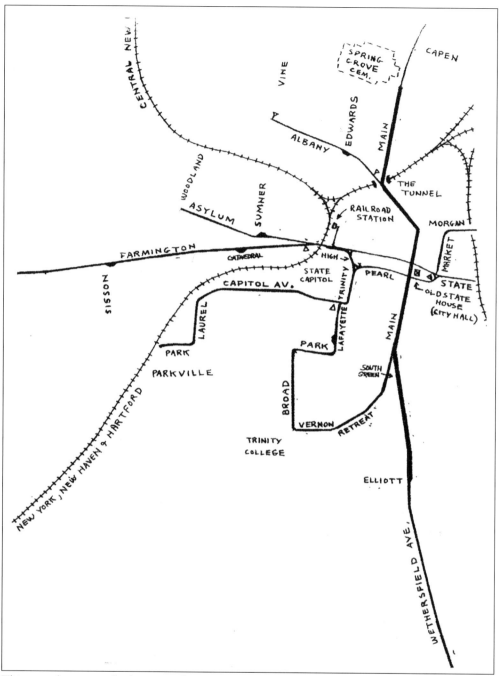

This map designates the horse-car lines in Hartford from 1863 to 1893.

One
THE HARTFORD
& WETHERSFIELD
HORSE RAILROAD

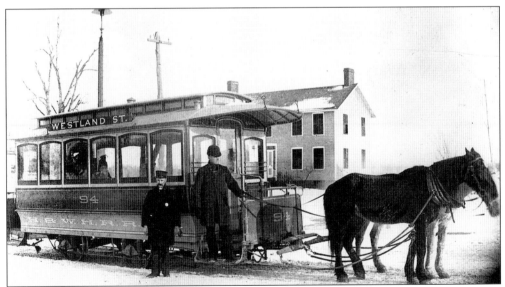

Hartford & Wethersfield Horse Railroad No. 94 is shown here at the end of the Main Street line at Westland Street c. 1890. This car was built by the J. G. Brill Company of Philadelphia, Pennsylvania. It was designed to be converted into an electric car when the lines were changed from horse to electric propulsion.

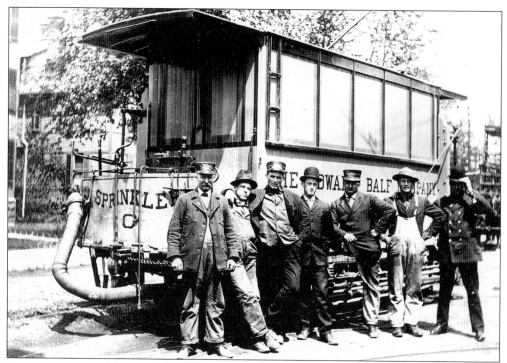

Streetcars were used for more than just moving people. This sprinkler car, owned by the Edward Balf Company, was used for dust control on routes traveled by dump cars that brought crushed stone from the Balf Newington quarry, located on the Hartford to New Britain line. These cars were manned by Connecticut Company crews.

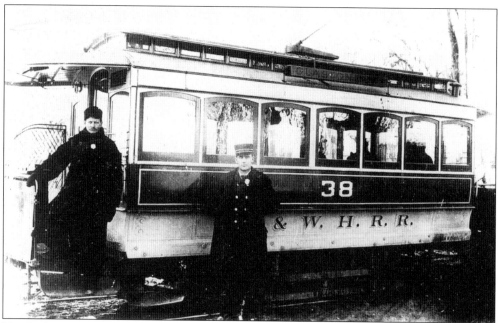

Hartford & Wethersfield Horse Railroad Car No. 38 is shown in this 1893 scene on the Glastonbury line. The name would soon change to the Hartford Street Railway.

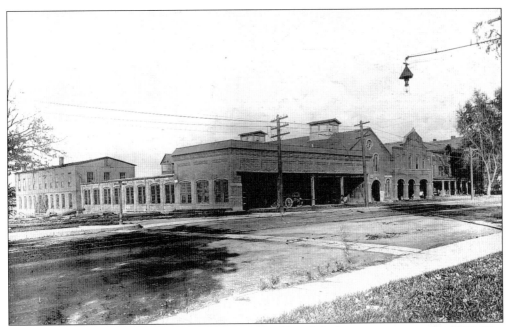

This photograph shows the Wethersfield Avenue stables of the horse-car company in 1898. The center portion was built in 1863 at the time the company started operation. This building was demolished in 1902 to make way for the car barn that still stands on Wethersfield Avenue today.

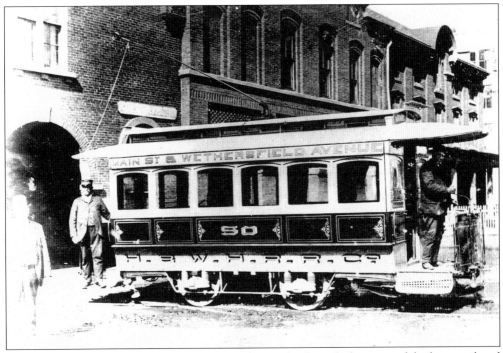

No. 50 was the first electric car to operate on the newly electrified section of the horse railroad and made its first run on September 21, 1888. Here, it is seen in front of the Wethersfield Avenue car house.

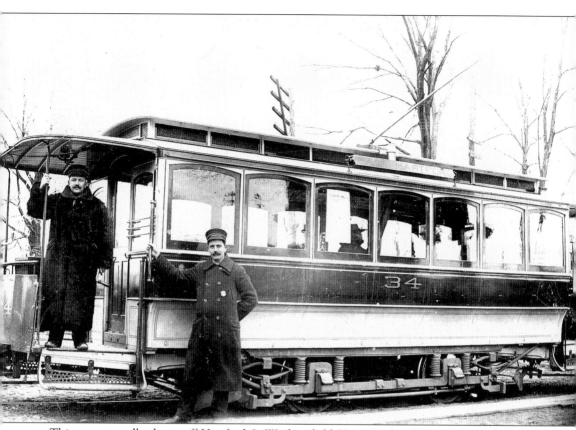

This crew proudly shows off Hartford & Wethersfield Horse Railroad Car No. 34 after it was converted to an electric car.

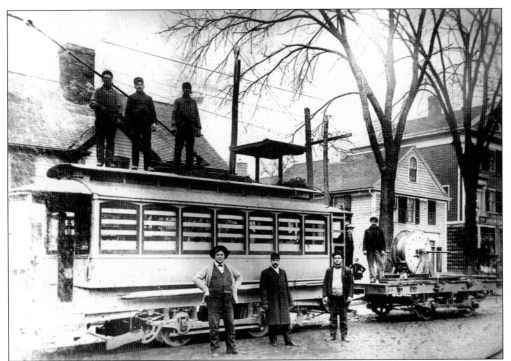

Electrification required the instillation of overhead wire to provide power for the cars. To accomplish this, some of the horse cars were converted for use by wire crews, as shown in this photograph taken in Wethersfield in 1888. The first line to be electrified ran from the Wethersfield Avenue stables to Wethersfield Green.

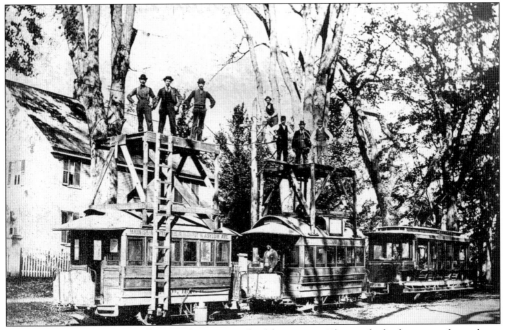

Some installations required more than a standard horse car. Elevated platforms, such as those in this 1888 photograph, were also used by crews.

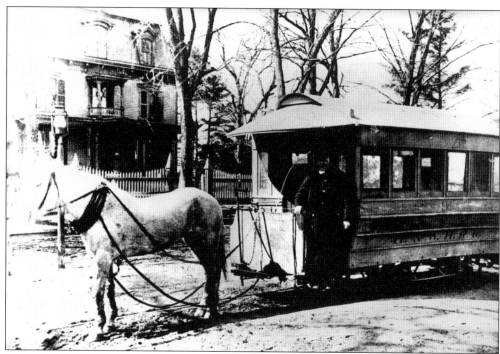

This is a good example of an early Hartford & Wethersfield Horse Railroad horse car, pictured *c.* 1875. This driver most likely became a motorman or conductor on the electric cars after 1894.

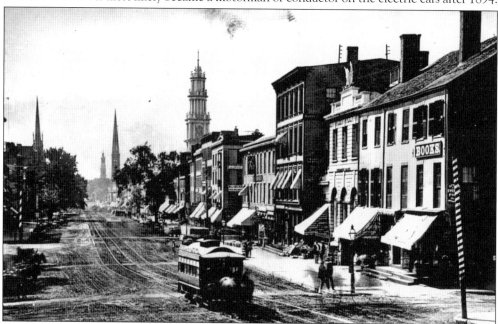

Three choices of transportation were available in Hartford in 1870. To get around town, one could walk, ride a horse, or take a horse car. Since horses were not normally owned by city dwellers, the best way of getting around was by riding the horse car. This mode of transportation, though convenient, was expensive—12¢ if you rode all the way to Wethersfield—when the average wage was about 15¢ an hour.

Two
HARTFORD 1895–1920

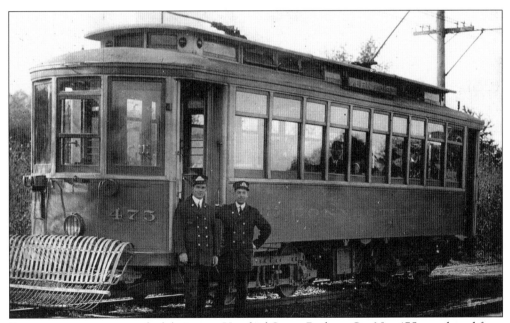

Streetcar crews were proud of their cars. Hartford Street Railway Car No. 475, purchased from the Wason Manufacturing Company in 1905, still showcased its original maroon color scheme in this view of Poquonock Avenue in Windsor. The car was later renumbered 844 and was scrapped in 1937.

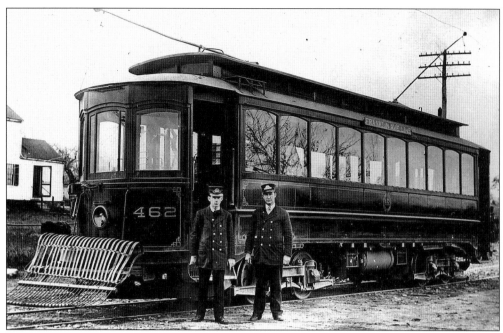

Car No. 462, seen here *c.* 1905, was painted Tuscan red when it was delivered by the Wason Manufacturing Company in 1901. After 1907, it was repainted the more familiar Connecticut Company yellow.

This 1904 scene on Ashley Street in Hartford was taken during some street repair work. Teams of horses continued to be used in construction projects. Motor trucks would not be popular for 10 more years.

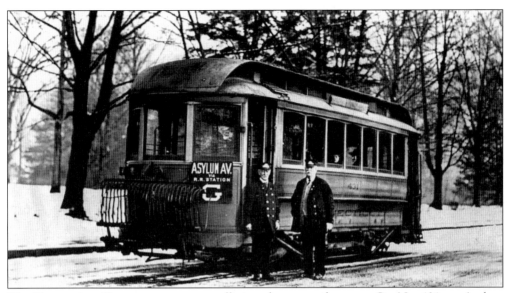

The Connecticut Company routes were all given letters, as shown on Car No. 431, an Asylum Avenue car at Woodland Street *c*. 1914. This car was built by the Cincinnati Car Company in the 1890s. These operators most likely started their transit careers on horse cars.

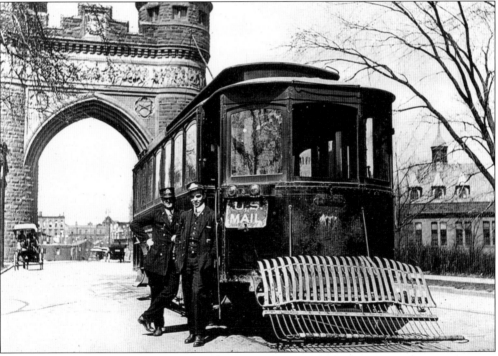

Car No. 197 is shown in this 1913 scene at the Soldiers and Sailors Memorial Arch on Trinity Street. Mail cars were not that common on the Connecticut Company lines, although mail was carried in the vestibule of passenger cars to the outlying post offices of Unionville, East Windsor Hill, South Glastonbury, and Stafford Springs. This car was renumbered 226 in 1915. It was converted to Sand Car No. 0256 *c*. 1920 and was scrapped in 1923. Street railway management used equipment in various capacities throughout the duration of ownership.

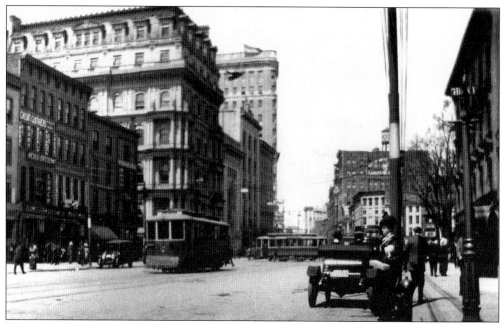

This view of the corner of Main and Pearl Streets in 1914 shows the scarcity of automobiles, as they were still out of the reach of most working people. Henry Ford was changing that with his Model T. Hartford was a bustling city in 1914, playing a major role in banking, manufacturing, and insurance.

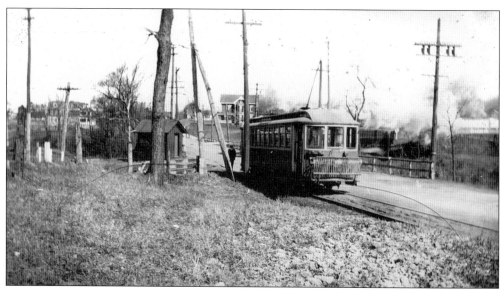

Once outside of downtown Hartford, the landscape became rural, as shown in this 1914 photograph of an inbound car on the Wethersfield line at the New Haven Railroad's Valley line crossing on Hartford Avenue.

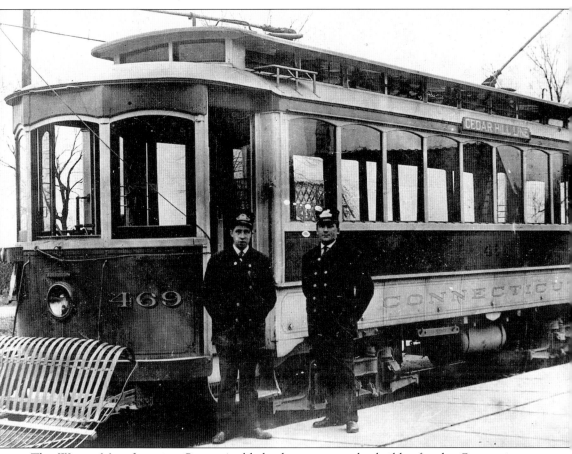

The Wason Manufacturing Company, likely the most popular builder for the Connecticut Company and its predecessors, built Car No. 469, shown here on the Cedar Hill line on Fairfield Avenue in 1912.

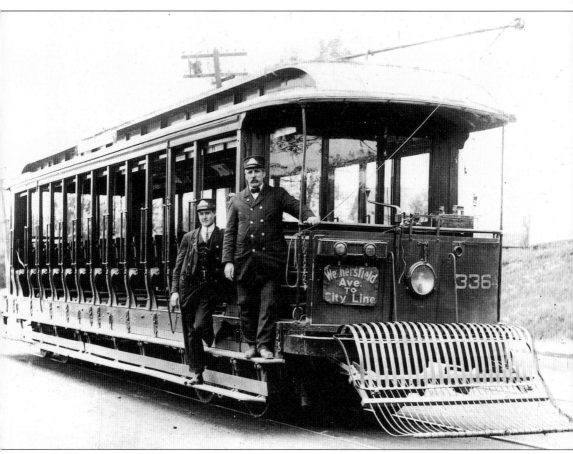

The hand-lettered sign tells us that this open car ran on Wethersfield Avenue when this photograph was taken in 1912. These cars were very popular with the riding public, as they offered a refreshing ride in warm weather. Car No. 336 was built in 1907.

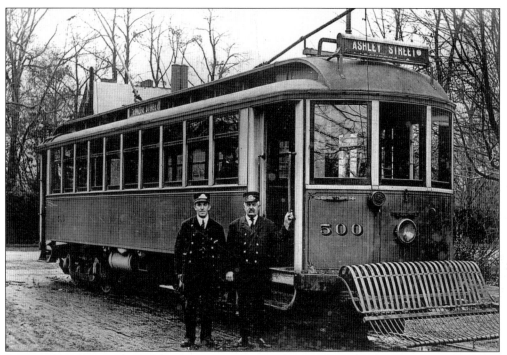

Car No. 500 rides on the Ashley Street line in 1910. During the renumbering program in 1915, it became No. 1218. Its old number, 500, was reassigned to the Connecticut Company parlor car, which traveled around the system mostly doing line inspections. No. 1218 was scrapped in 1936.

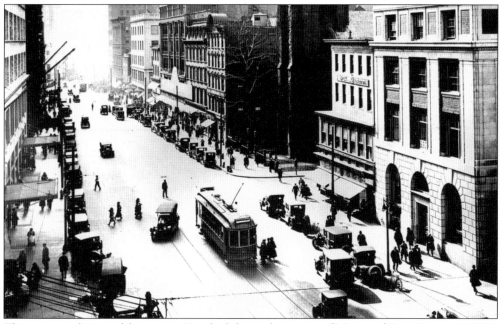

This rare aerial view of downtown Hartford shows the corner of Main and Pratt Streets in 1914, where early automobiles, pedestrians, and trolley cars shared the road.

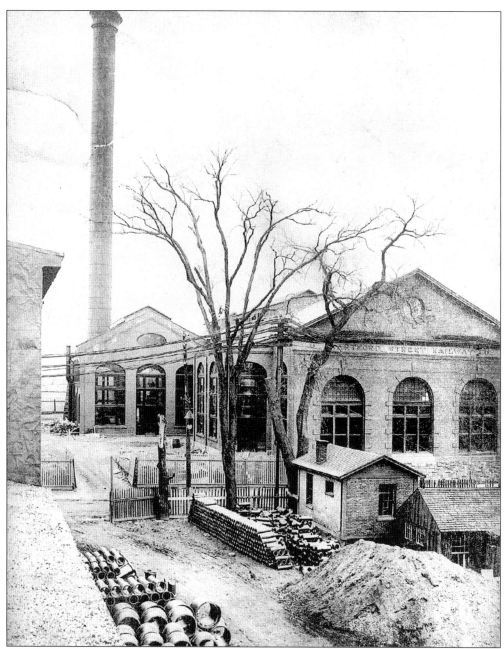

The Hartford Street Railway Commerce Street power station, seen here *c.* 1908, was the primary power source for the streetcar lines that served Hartford. The station had three DC generators that fed 600 volts DC directly into the overhead wire and three AC generators that fed 11,000 volts AC to substations in Rockville, Buckland, and Unionville for conversion into 600 volts DC. The station burned coal, which came into Hartford by barge up the Connecticut River from Port Reading, New Jersey. This facility stopped generating its own electricity in the early 1930s, after which the Connecticut Company purchased power from the Hartford Electric Light Company. The building was torn down in 1941 in conjunction with the building of the dike system on the Connecticut River.

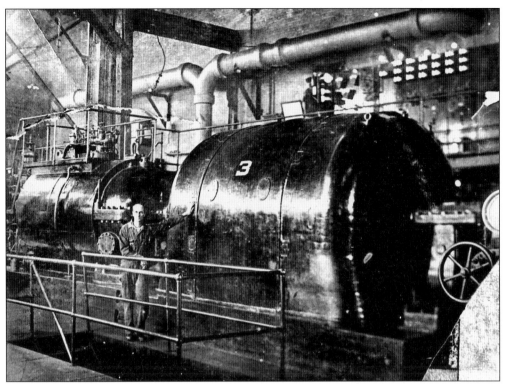

Turbine No. 3 was one of two installed at the Commerce Street power station in 1908. These units turned the generator, which then generated AC electricity for distribution to the outlying substations.

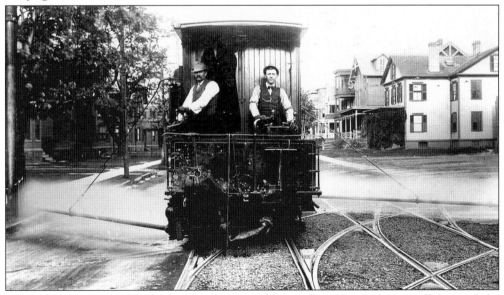

Before the beginning of the 20th century, most of the roads in Hartford were still dirt, and the main form of transportation was by horse. During the dry summer months, the streets were dusty. Sprinkler Car No. 0, seen here on Vernon Street in 1898, sprinkled dusty streets and facilitated the removal of horse droppings.

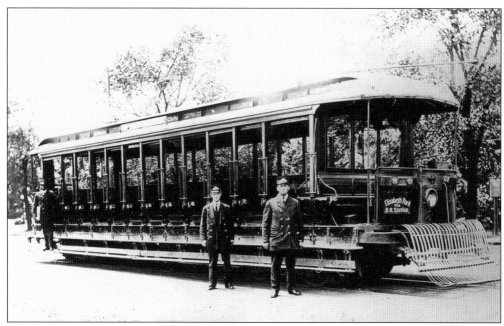

The Elizabeth Park rose gardens were world famous and undoubtedly helped increase ridership, especially during the summer months. The land for the park was donated by Charles Pond to the city of Hartford and was named in honor of his wife. Most of the park is actually located in the town of West Hartford. Car No. 335 rests at the entrance to the park. The line continued a few more blocks to St. Mary's Home on Steele Road. The African American gentleman at the back of the car is not identified, but the conductor was Mr. Bremor (left) and the motorman was Mr. Jenson (right).

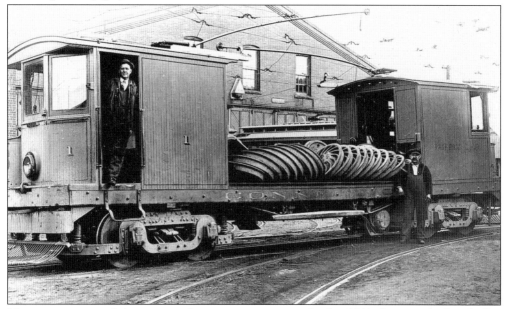

Many cars were needed to support the streetcar operation. In this 1911 photograph, Supply Car No. 1 carries a load of supplies at the Vernon Street car barn. This car became No. 0234 in the 1915 renumbering of Connecticut Company equipment.

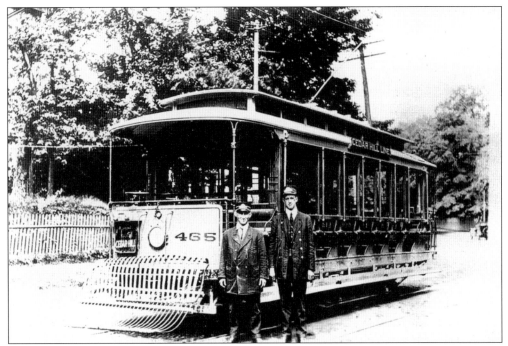

The crew poses with single-truck Open Car No. 465 during a layover at the Cedar Hill Cemetery at the end of the Fairfield Avenue line. Several notables are buried at Cedar Hill, among them J. P. Morgan, Samuel Colt, and poet Wallace Stevens. The Fairfield Avenue line was converted to a bus route in 1935.

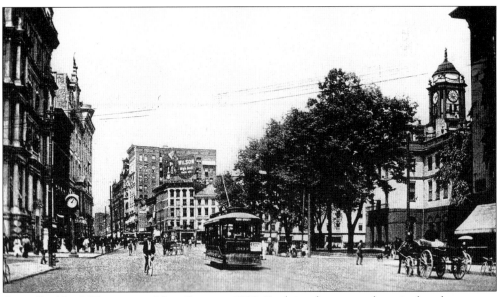

Open Car No. 207 is seen on Main Street *c.* 1900. Evolving from an early agricultural economy, Hartford had grown into an important business, insurance, and manufacturing city by 1900.

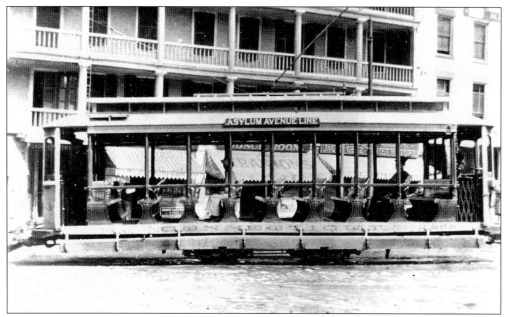

One of the shortest streets in Hartford is American Row, which only had one building on it in the streetcar days: the American Hotel. Open Car No. 259 runs around Hartford City Hall (now the Old State House) to the Isle of Safety and Asylum Avenue.

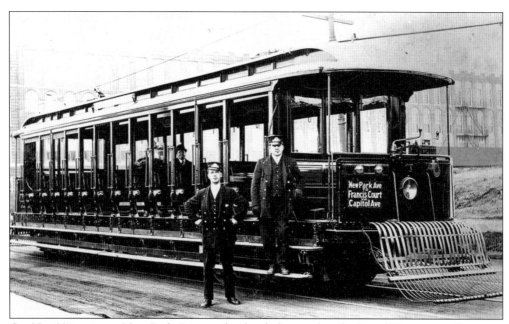

Car No. 331 waits on New Park Avenue for the shift to end at the Royal Typewriter Company in 1937. More than 5,000 people worked in this building at one point in time.

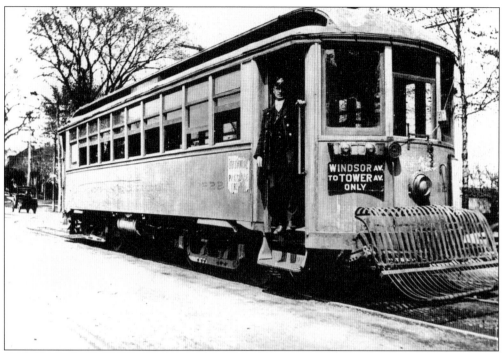

Car No. 1222 waits at the Tower Avenue crossover on Main Street. The operator will soon return to downtown by using the crossover switch behind the car. Runs that turned back midway on the route were quite common when ridership was heavy.

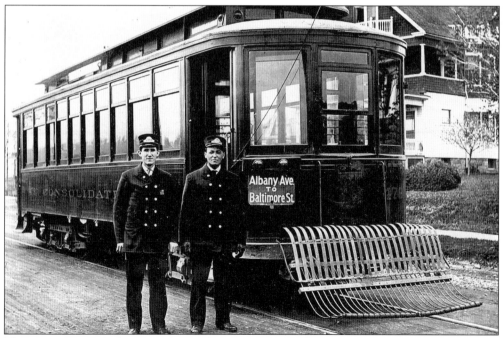

This car prepares to change ends at Baltimore Street on the Albany Avenue line.

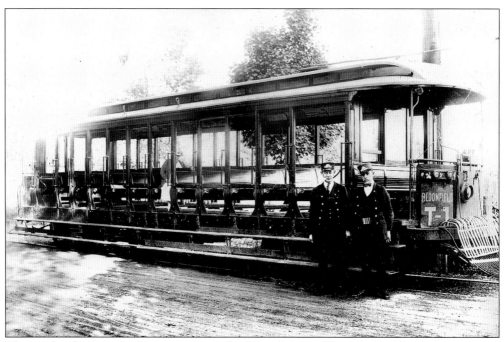

This undated photograph shows the end of the line in Bloomfield. This two-man crew demonstrates one of the reasons why it was becoming too costly to operate open cars. Closed cars could be converted to one-man operations, but open cars could not because of the safety issues of passengers riding on a car with no sides or door. Open cars had two-man crews right up until they stopped running in New Haven in 1946.

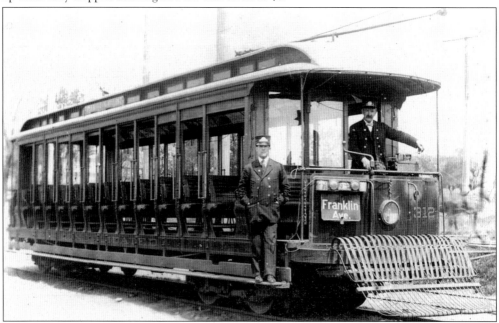

Consolidated Railway No. 312 was built in 1906 by the Wason Manufacturing Company. Open cars such as this one were only operated during warm weather. This car later became Connecticut Company No. 892.

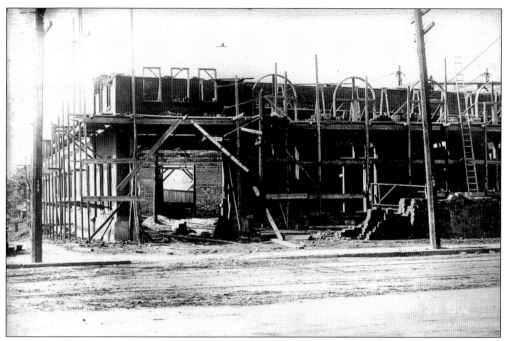

Shown here is the construction of the new Wethersfield Avenue car barn in 1902. The car barn replaced the horse-car stables built on the same site in 1863. This building still stands in 2004, although it is now a commercial building and no longer used for the storage of transit vehicles.

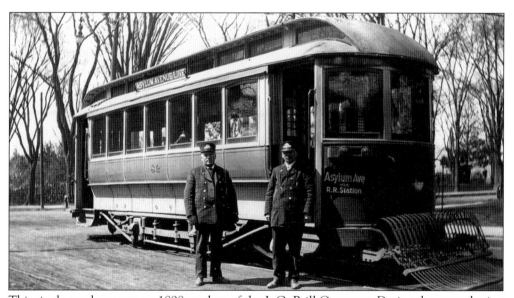

This single-truck car was an 1898 product of the J. G. Brill Company. During the renumbering in 1915, it became No. 430. The Asylum Avenue line was the first streetcar line to be converted to motor coach.

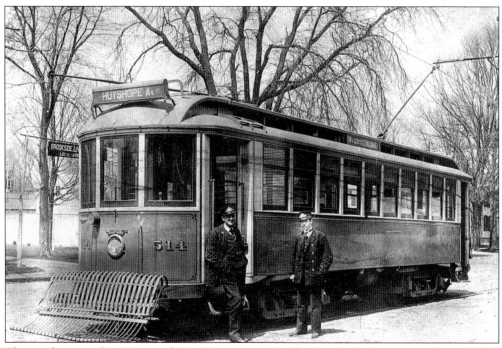

The conductor and motorman of No. 514 seem to enjoy having their photograph taken in 1914.

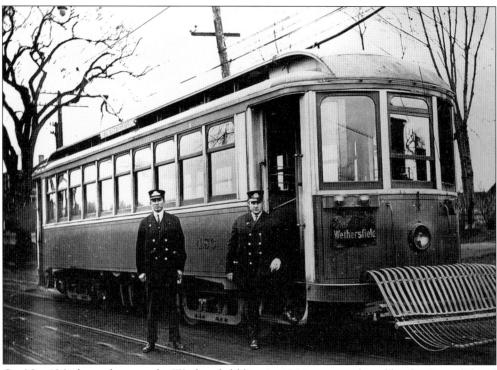

Car No. 486, shown here on the Wethersfield line in 1914, was purchased by the Consolidated Railway in 1906. It was scrapped in Hartford in 1937.

Three
HARTFORD 1921–1941

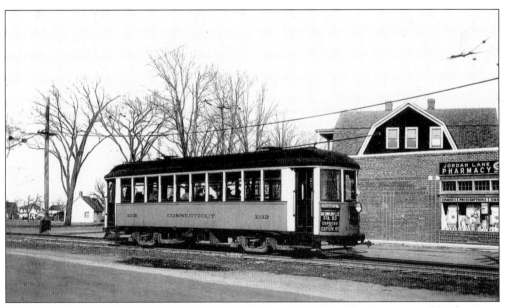

This 1938 photograph shows Car No. 1313 at the corner of Franklin Avenue and Jordan Lane in Wethersfield. This was the former line to Middletown.

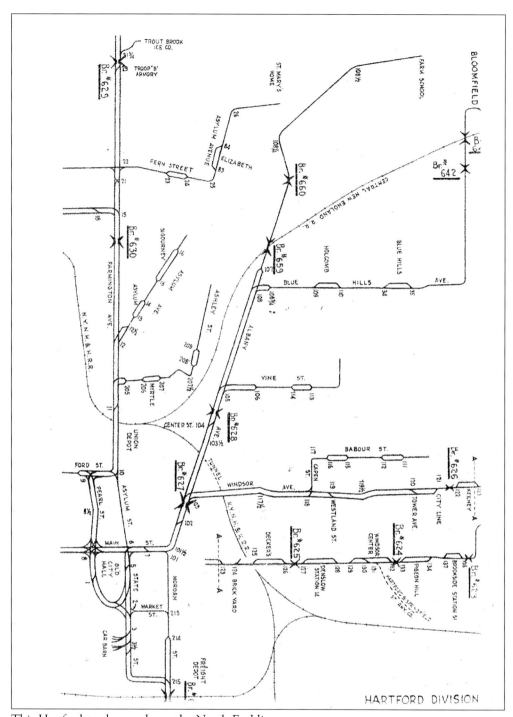

This Hartford track map shows the North End lines.

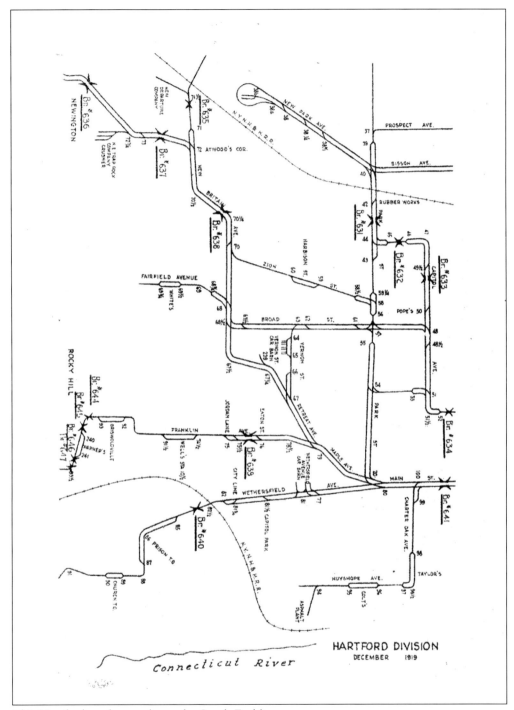

This Hartford track map shows the South End lines.

The Edward Balf Company was located at the end of the Huyshope Avenue line. Although this line was used for passengers, the Edward Balf Company was a customer of the Connecticut Company. Crushed stone was delivered regularly to the company's asphalt plant by railway cars.

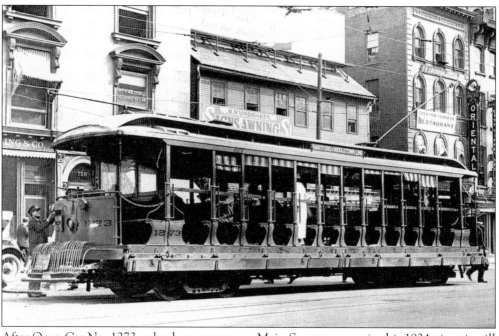

After Open Car No. 1273 unloads passengers on Main Street, as seen in this 1924 view, it will run around Central Row to return to Middletown. On page 2, this same car is seen as No. 355 before the 1915 renumbering.

Car No. 951 passes the state capitol and will soon turn onto Trinity Street on its way to Central Row. No. 951 was the former Rockville Interurban Car No. 5 and was very popular with trolley fans in Hartford since it was used for numerous special runs before the lines stopped operating in 1941.

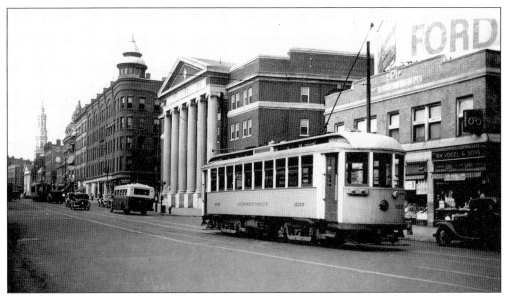

The Central Baptist Church is shown in this 1936 scene on Main Street in Hartford. Most of the buildings in this photograph still remain in 2004.

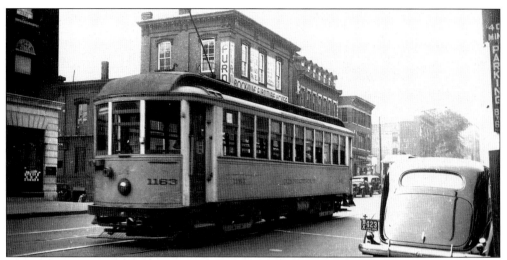

Car No. 1163 passes Hartford Fire Department Engine Company No. 3 on Market Street in 1936. This car, formerly No. 30 on the Farmington Street Railway, was built by Wason in 1907.

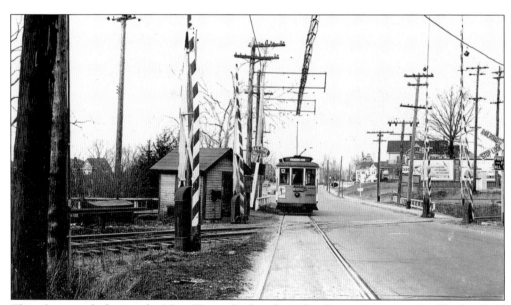

This photograph depicts the New Haven Railroad's Valley line as it crosses the Wethersfield line in 1939. On page 20, the same scene is shown in 1914.

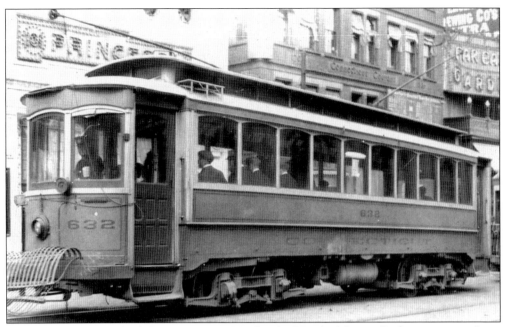

Closed Car No. 632, built by Wason in 1901 for the Hartford Street Railway, runs on State Street. As the Hartford system started to shrink in the early 1930s, these older cars were some of the first to be scrapped. More than 100 cars like No. 632 were scrapped in Hartford in 1936 and 1937.

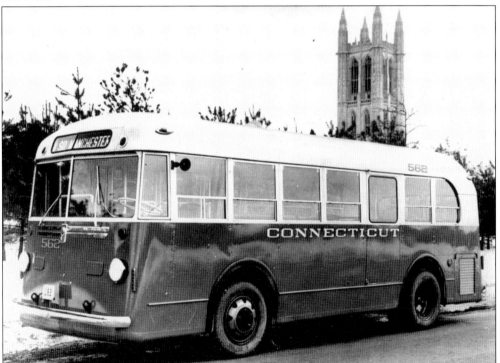

Yellow Coach built No. 562, a 27-passenger bus, to help convert all the remaining streetcar lines in Manchester in 1939.

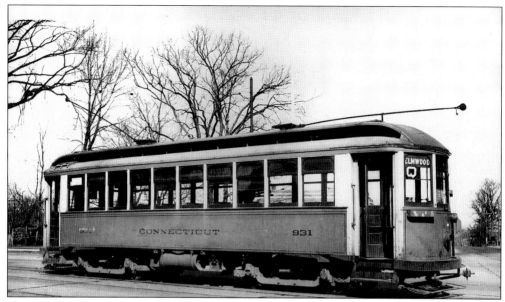

Car No. 931 sits at the end of the Elmwood line on New Britain Avenue and South Quaker Lane in this 1937 view.

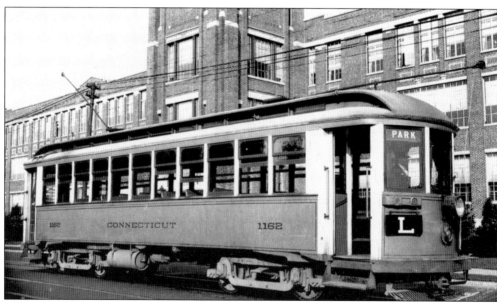

The Fuller Brush plant is in the background of this 1934 photograph of Car No. 1162, a former Farmington Street Railway car. This was the turn-back point on the Windsor line for every other car coming from downtown. Many thousands of employees worked at the plant and used the streetcars to get to work.

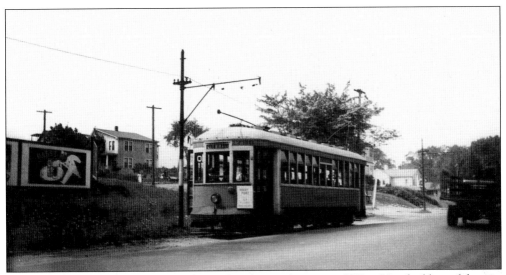

This car runs on New Britain Avenue in the Elmwood section of West Hartford bound for city hall in 1937.

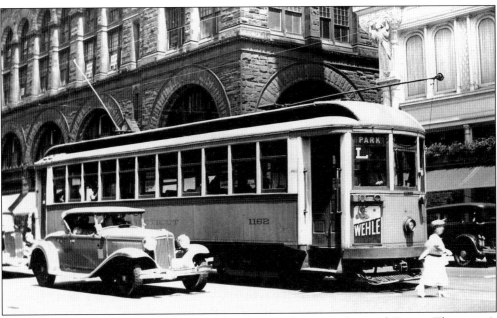

Pedestrians, roadsters, and trolley cars share Main Street in front of Brown Thompson's Department Store. The structure, designed by famed architect Henry Hobson Richardson, was originally called the Cheney Building.

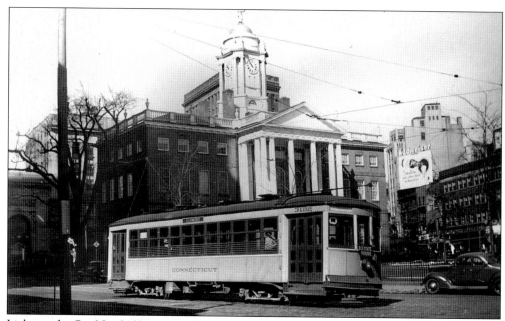

Lightweight Car No. 3122 passes in front of the Old State House as it rounds Central Row on the way to the Isle of Safety. Built in 1796, the Old State House served as both Connecticut's capitol and Hartford City Hall, and was the focal point of downtown.

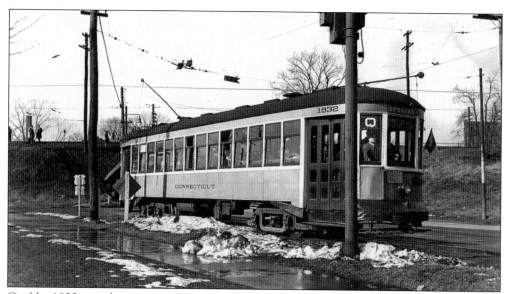

Car No. 1832 completes a special run on the New Britain Avenue line in the Elmwood section of West Hartford. Trolley cars were often chartered for special outings, usually for recreational purposes. The New Haven Railroad embankment appears in the background. New Britain Avenue service was converted to bus on May 18, 1941.

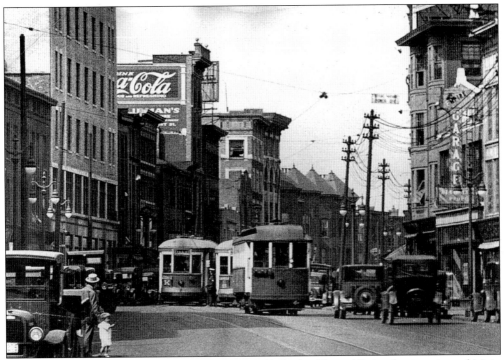

Shown here is Main Street north of the area called "the Tunnel." At the junction of Main Street and Albany Avenue and the New Haven Railroad main line to Springfield, the railroad line ran under the streets in a 500-foot-long tunnel, giving the area its name.

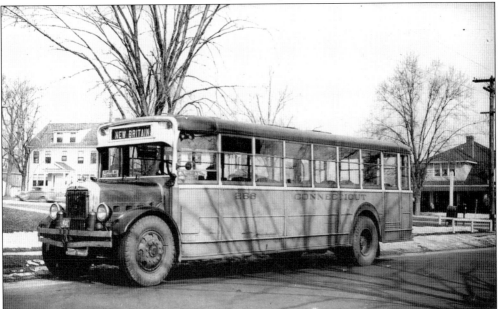

Yellow Coach Model Z240 runs on the New Britain Avenue line in 1934. Buses gradually began to replace streetcars in Hartford. On lines with heavier ridership, streetcars were still used because they could accommodate more people. Buses of the era normally carried 36 or fewer passengers; the typical closed streetcar in the 1930s held 50 passengers.

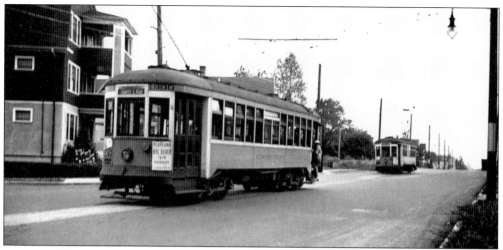

Cars No. 1800 and 1802 pass on New Park Avenue in 1937. Car No. 1802 is preserved today at the Shore Line Trolley Museum in East Haven.

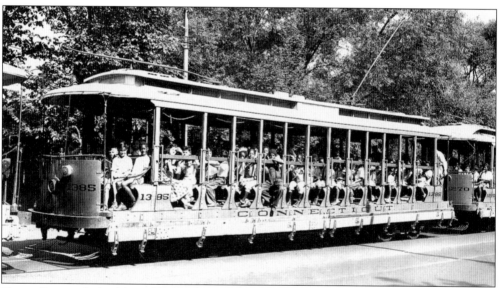

Camp Courant helped keep Hartford's open cars on the equipment list long after they were removed from regular service. During school vacation in July and August, children from all over the city were taken to the camp on Park Road, Monday through Friday mornings, and then returned home again at night. One hundred or more children could be loaded on one open car, so the streetcar remained a very efficient method for transporting children.

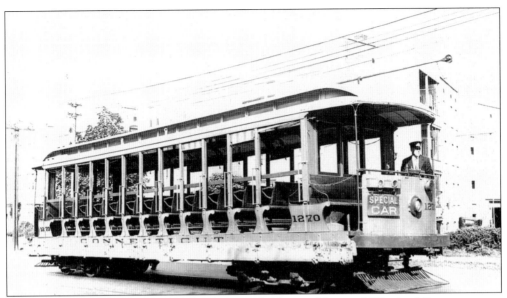

This special open car had the job of picking up children at Main and Westland Streets to go to Camp Courant in 1935.

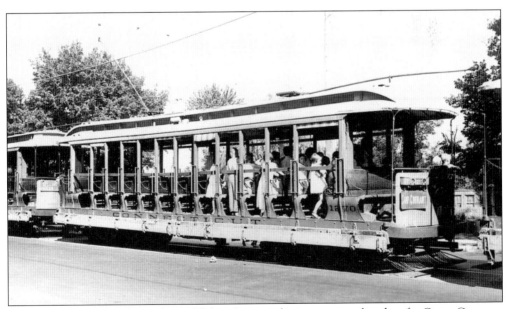

This 1935 scene on Park Road near Walter Avenue shows open cars lined up for Camp Courant.

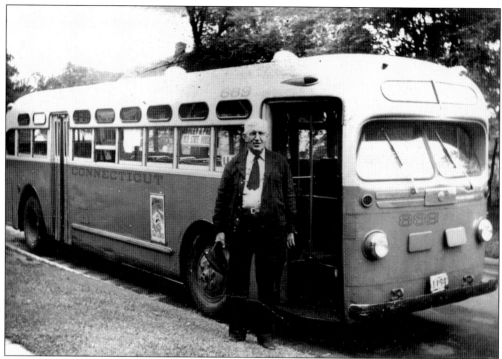

Yellow Coach No. 889 was part of the 100-bus order made with the Yellow Coach Division of General Motors in 1941 to replace the streetcars of Hartford. The operator in this photograph is Raymond Benheimer, a longtime employee of the Connecticut Company. He later became the chief supervisor of the Hartford Division.

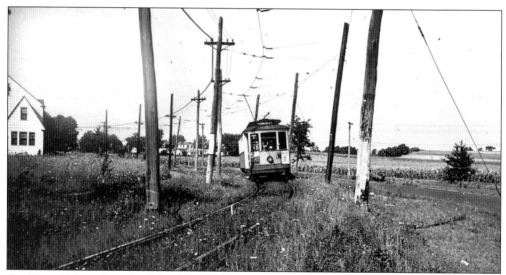

Car No. 1556 is inbound to Hartford on the Griswoldville line in 1937. This was originally the Middletown line through Wethersfield and Rocky Hill. Service to Griswoldville ended in 1941.

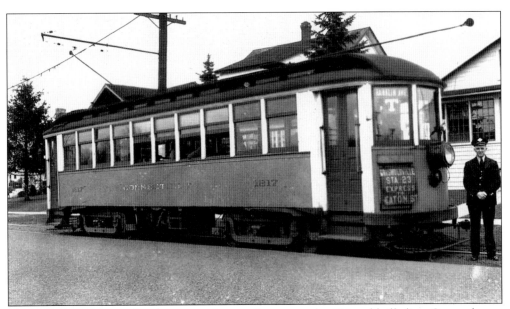

Car No. 1217 is pictured with operator Lyman Saxton on the Griswoldville line. Saxton began work for the Connecticut Company in 1917; in 1960, he was still shown on the list of active bus operators.

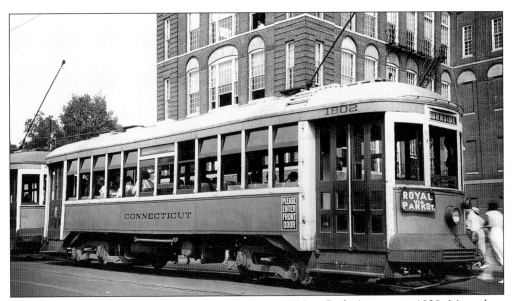

The shift ends at the Royal Typewriter Company on New Park Avenue in 1938. More than 5,000 people worked in this building in the 1940s. Hartford also was home to the Underwood Typewriter Company, which employed more than 6,000 people in the same period. Underwood employees had the choice of the Capital Avenue or Park Street lines to get to work.

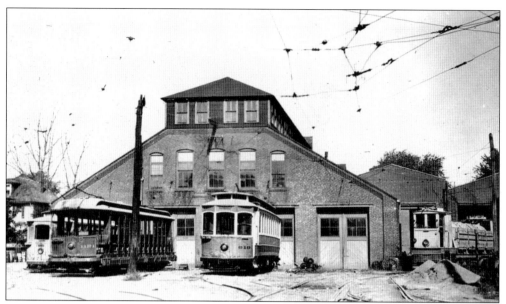

Seen here is the back of the Vernon Street shops in Hartford. This facility was originally a horse-car stable, although the buildings shown in this photograph were built as an addition with the purpose of maintaining streetcars. These buildings were last used to maintain and store buses until the facility was relocated to the North Meadows section of the city in 1990.

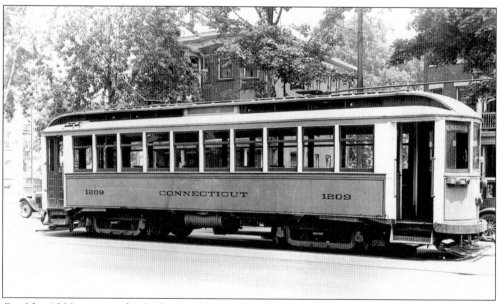

Car No. 1209 runs on the Park Street line in this 1935 view. Park Street was a busy business district selling everything imaginable in the streetcar days.

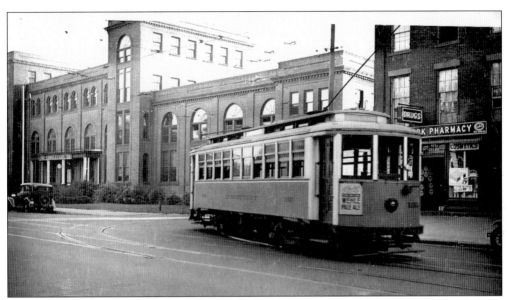

The Wethersfield Avenue car barn, seen here in 1938, was constructed on the site of the Hartford & Wethersfield Horse Railroad stables in 1902.

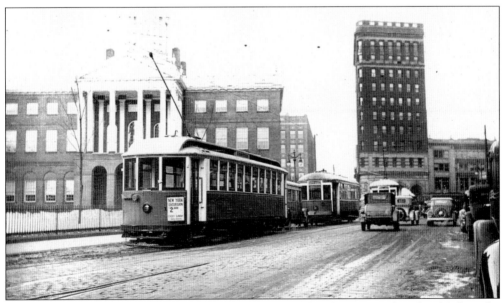

This scene depicts State Street in 1936. Cars line up at the platform at the Isle of Safety, the major transfer point in the city. All streetcar and most bus routes passed this location.

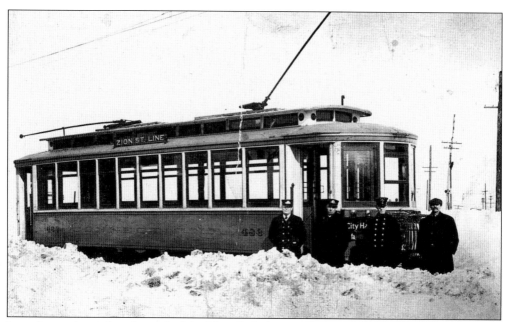

Luna Loop, situated at the end of the New Park Avenue line, was the site of the gathering of this unidentified group in 1909. The location took the name of the amusement park located on New Park Avenue, where the present Home Depot store sits. This was also the location of a harness-racing track called Charter Oak Park. The amusement park closed by 1918, and the harness-racing track closed in 1940.

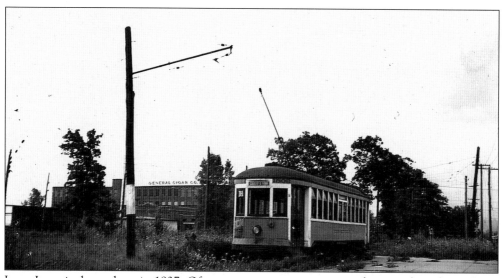

Luna Loop is shown here in 1937. Often a streetcar company put a loop track at the end of a line to allow cars to turn around; Luna Loop is an example of this.

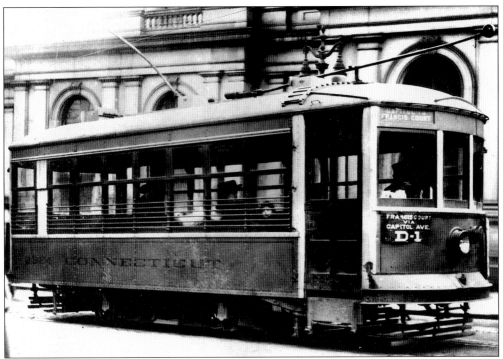

Single-truck Safety Car No. 2324 was a 1920 product of the Osgood Bradley Car Company of Worcester, Massachusetts. These cars were much less expensive to operate than the older double-truck wooden cars, but the ride was very rough and not too popular with the public. They were called safety cars because of their special features designed to prevent accidents and stop the car in the event that the operator was immobilized because of illness or accident.

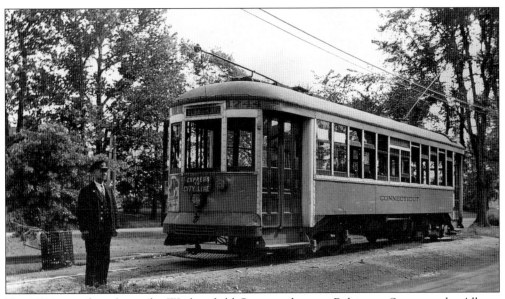

No. 1744 is ready to leave the Wethersfield Green and run to Baltimore Street on the Albany Avenue line.

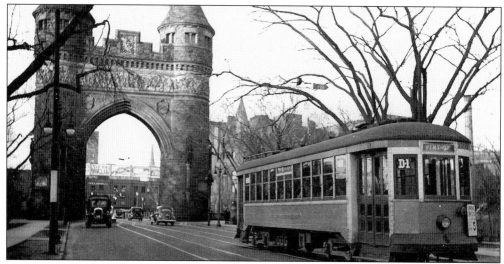

Compare this 1937 Trinity Street scene with the 1913 scene on page 19. The Soldier and Sailors Memorial Arch was designed by Hartford architect George Keller to honor the 4,000 Hartford citizens who served in the Civil War. The Gothic monument is made of Portland brownstone and cost $60,000 to build in 1886.

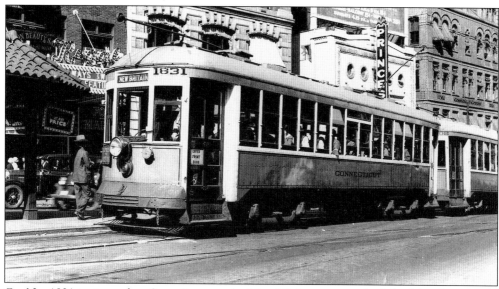

Car No. 1831 is pictured on State Street at the Isle of Safety, seen in the left of the photograph.

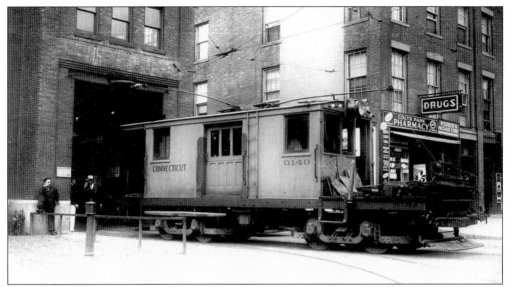

Hartford Division Wrecker No. 0140 exits the Wethersfield Avenue car barn. Built in 1904 by the Vernon Street shops of the Hartford Street Railway, these cars carried tools and equipment for re-railing streetcars and towing disabled cars back to the shop.

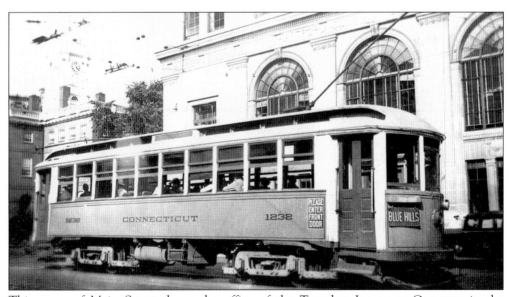

This scene of Main Street shows the office of the Travelers Insurance Company in the background. More than 10,000 people worked in this building in the late 1930s, giving much business to the streetcars of Hartford.

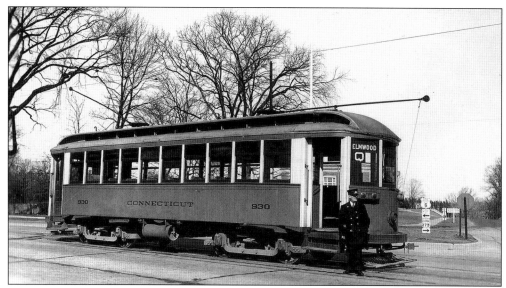

This car waits on New Britain Avenue at South Quaker Lane in the Elmwood section of West Hartford. The area remained fairly rural in the 1930s with farms still operating in the neighborhood.

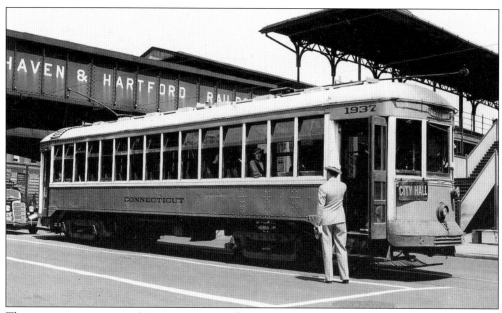

This extra car, waiting at Union Station, will soon depart for the Old State House and the Isle of Safety to transport arriving New Haven Railroad passengers to their final destinations in Hartford.

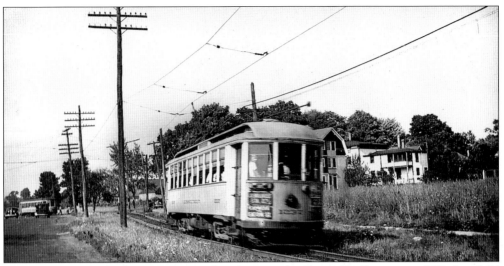

Car No. 1337 speeds along a private right of way in the Griswoldville section of Wethersfield in 1937.

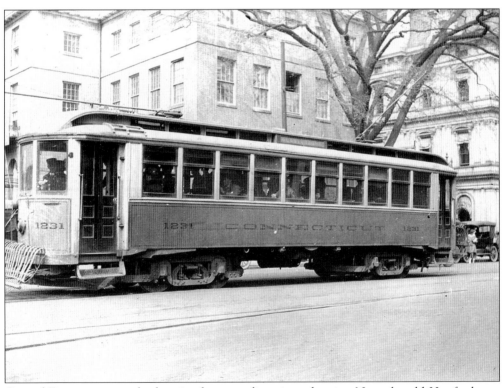

Central Row was a turn-back point for many lines into the city. Note the old Hartford post office in the background, which was built on the front lawn of the Old State House.

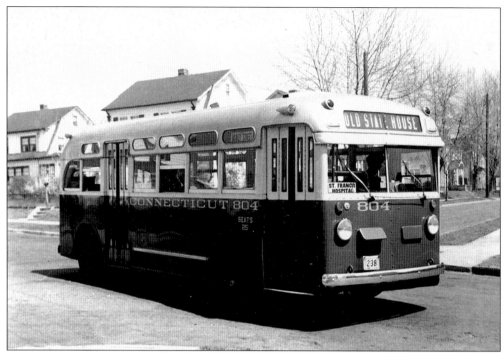

Yellow Coach Bus No. 804, shown here on the Ashley Street line in Hartford, was delivered in 1941 to help motorize the remaining streetcar lines in the city.

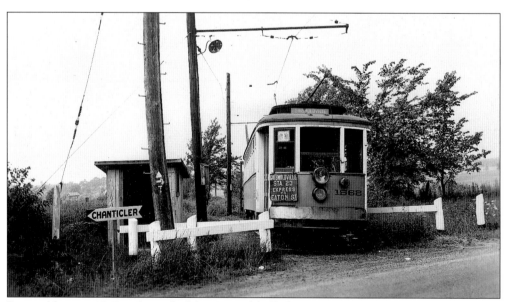

Pictured here in 1940 is the end of the Griswoldville line in Wethersfield.

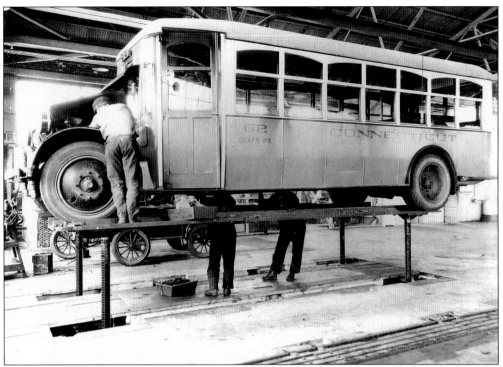

Early Motor Coach No. 62, built by the Fageol Safety Coach Company in 1924, appears in the Vernon Street shops in 1938. The Connecticut Company had two Columbia Host lifts in the Vernon Street shops, which facilitated repairs on the buses. In contrast, the trolleys were repaired using pits in the floor.

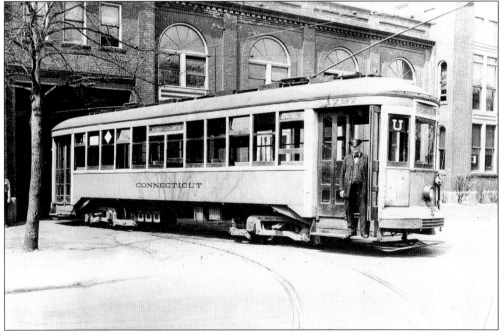

Operator Daniel Hagerty is seen with Car No. 1797 at the Wethersfield car barn.

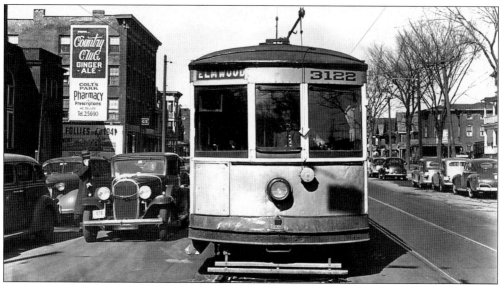

Car No. 3122 runs on Wethersfield Avenue in 1939. Located near this scene, Buckeley Stadium was the home of Hartford's minor-league baseball team, variously known as the Hartford Chiefs, Hartford Senators, Hartford Laurels, and the Hartford Bees. Teams played there from 1921 to 1952. Lou Gehrig was a member of the Hartford Senators 1923 team, and Babe Ruth played at Buckeley Stadium in an exhibition game in 1940. Streetcars were no doubt full on days that the team played home games. Before Buckeley Stadium was built, the game was played at the Hartford Baseball Club near Colts Park. Before 1914, Hartford had a local ordinance forbidding ball games on Sundays. When a game was scheduled on Sunday, it was played at Piney Ridge Park in East Windsor, located on the Hartford & Springfield Street Railway. Cars ran directly from Hartford to the park on these Sundays.

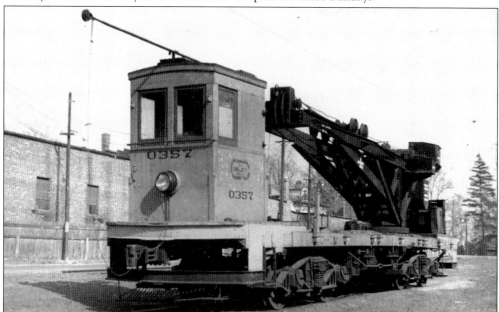

Hartford Crane Car No. 0357 is seen here at the Wethersfield Avenue car barn. A streetcar company needed various types of equipment, such as cranes, to maintain the track.

Track work is completed on Capen Street in 1938. The Capen Street line operated for only three more years, yet the company was still doing substantial repair work there.

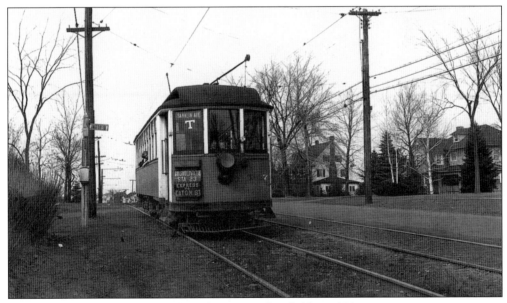

Car No. 1237 is pictured at Well's Siding in Wethersfield in 1939.

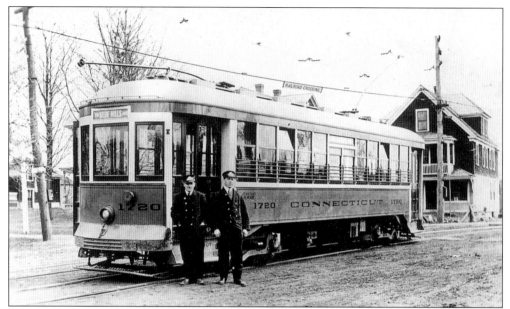

Car No. 1720, built in 1915 by the Wason Manufacturing Company, is an example of a semi-convertible car because of the way the windows folded up into the body to create a ride similar to that of an open car in warm weather. This type of car, which could be run by a one-man crew, took the place of the open cars on most streetcar systems because of the reduced crew size.

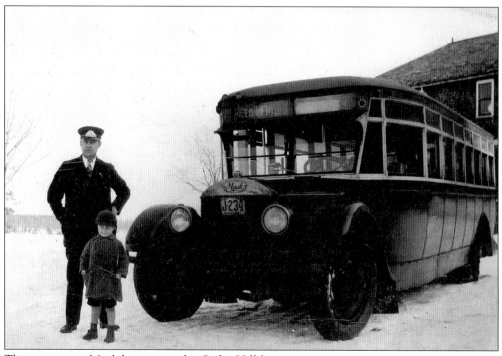

This impressive Mack bus ran on the Cedar Hill line.

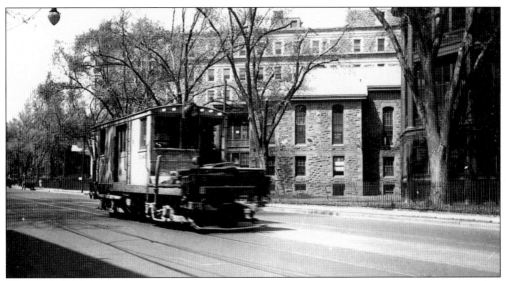

Work Car No. 0140 runs on Retreat Avenue in 1936. Hartford Hospital appears in the background.

Out-of-uniform bus operators Dave Roehe (left) and John Reynolds (right) are shown in this 1937 view with Connecticut Company Reo Bus No. 1.

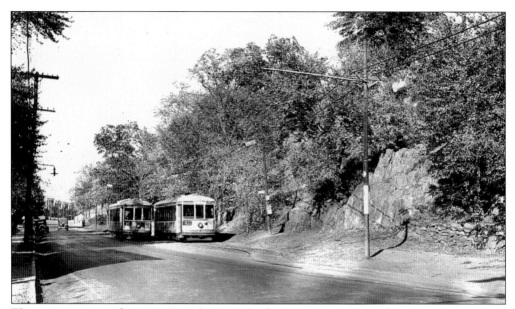

These streetcars are shown on Zion Street at Harbison Avenue on October 13, 1935. On April 30, 1939, Zion Street trolley service was discontinued. The new bus route then operated via Hillside Avenue rather than Zion Street.

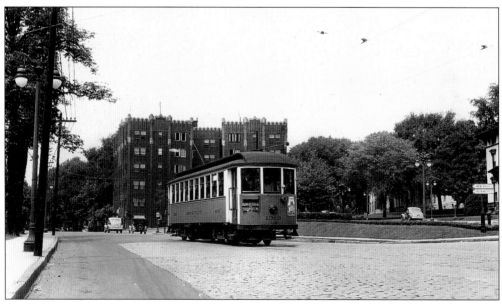

Car No. 1315 shares this scene with the Netherlands Hotel (in the background) at the junction of Farmington Avenue and Asylum Street.

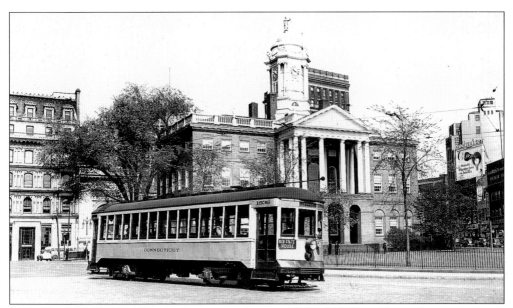

The old Hartford post office has been torn down, and the Old State House front entrance is visible again in this 1937 scene. Car No. 1939 was part of an order placed with the J. G. Brill Company in 1919. These cars provided the bulk of the service on the suburban lines out of Hartford in the 1920s and 1930s.

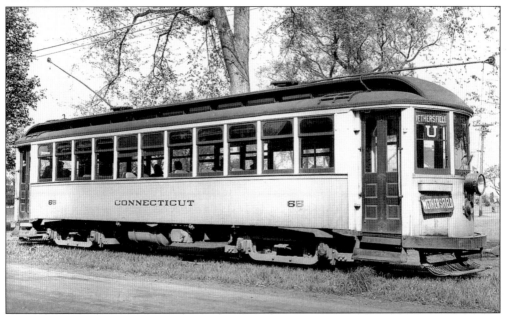

A layover occurs for Car No. 65 at the end of the Wethersfield line in 1939. This car came to Hartford from the Putnam Division when it closed in 1925. Instead of loading it on a flatcar and shipping it via railroad, No. 65 ran under its own power from Putnam to Hartford via Worcester and Springfield. The route took it on the Worcester Street Railway to Palmer, Massachusetts, the Springfield Street Railway to Springfield, and finally south on the Hartford & Springfield Street Railway to the Connecticut Company's East Windsor Hill line. This car survives today at the Connecticut Trolley Museum in East Windsor.

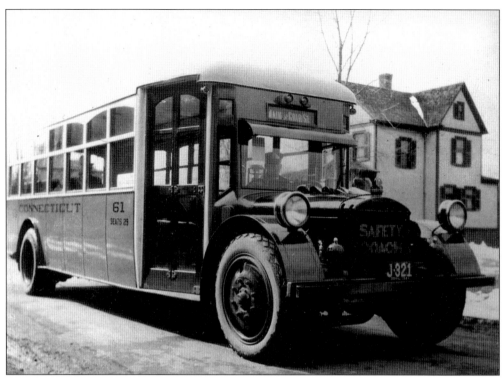

Fageol Safety Coach No. 61 was one of the early buses used to replace streetcars. Many of these older buses ran well into the 1930s.

Car No. 851 changes ends at the completion of its run on Farmington Avenue in this 1930 photograph. The car was built in 1905 and was scrapped in 1936, along with numerous other early wooden cars that were no longer needed in the shrinking streetcar system in Hartford.

Four
EAST OF THE RIVER

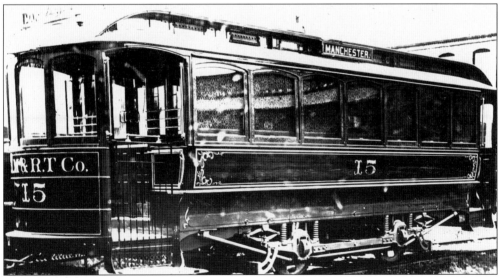

Hartford, Manchester, & Rockville Tramway's 20-foot-long Closed Car No. 15 was delivered by the Wason Manufacturing Company in 1895. The Hartford, Manchester, & Rockville Tramway was purchased by the Consolidated Railway in 1906, and this car was renumbered 299 in 1915.

This view was taken on July 13, 1914, looking south on Main Street at Church Corners in East Hartford during a track construction project.

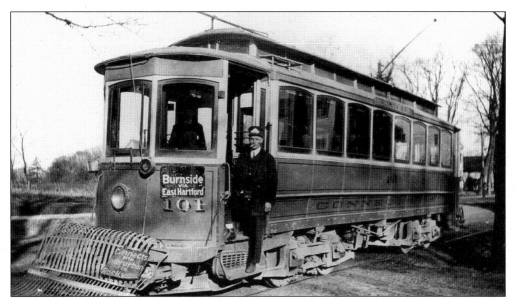

Connecticut Company Car No. 101 runs on Church Street in the Burnside section of East Hartford in 1914. The car was renumbered 443 in 1915 and was later converted into a work car and renumbered again to 0318. The conductor on the step is Charles Simpson.

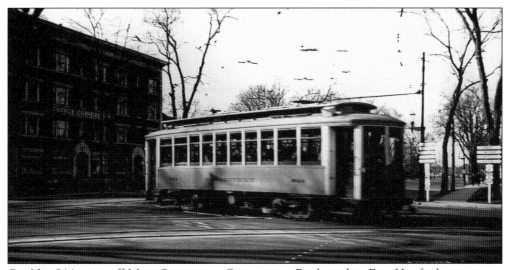

Car No. 844 turns off Main Street onto Connecticut Boulevard in East Hartford en route to Hartford from Glastonbury in 1936. This car was a former Hartford Street Railway car built in 1906.

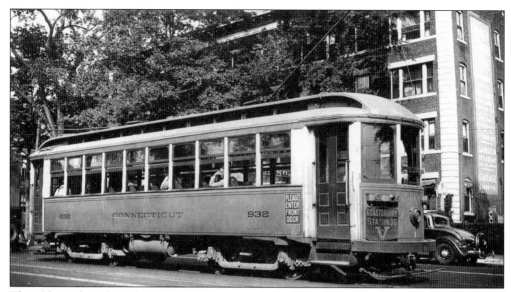

This Glastonbury-bound car appears in front of the Church Corners Inn. This building still stands in 2004.

This 1902 view of Hartford Avenue looks west. The street was renamed Connecticut Boulevard in the 1930s.

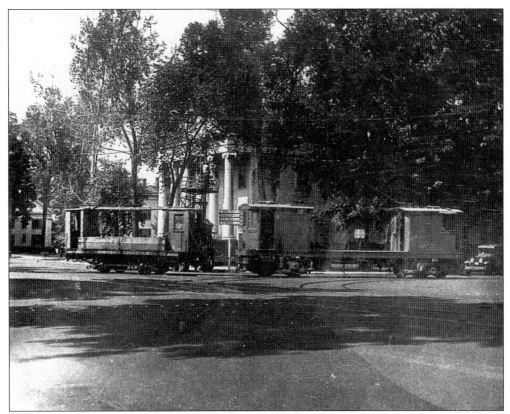

In this 1915 photograph, Work Car No. 1 is seen at Church Corners in East Hartford. The First Congregational Church has long been an East Hartford landmark.

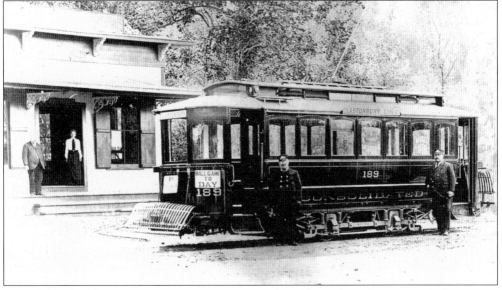

Consolidated Railway No. 189 appears at Station 35 in Glastonbury Center in 1906.

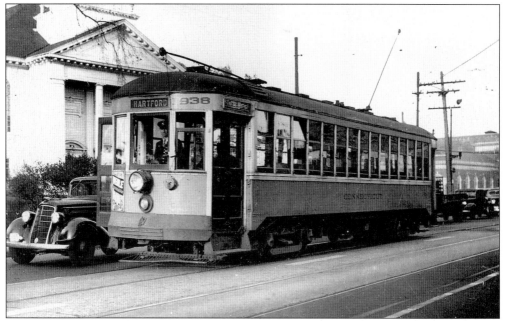

Car No. 1932 is en route to Hartford via Main Street in Manchester in 1938. Many of these buildings can still been seen today.

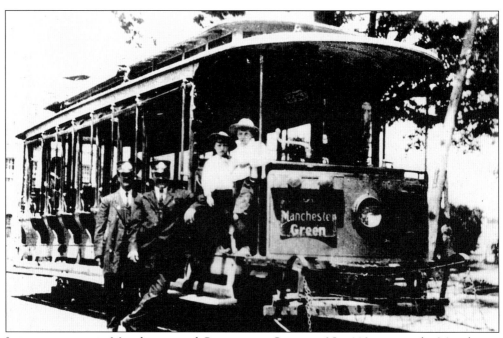

It is summertime in Manchester, and Connecticut Company No. 110 runs on the Manchester Green line. This line began operating on September 14, 1909, and was converted to bus operation on June 8, 1929.

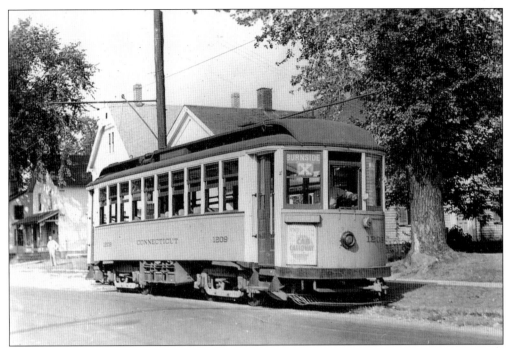

The operator of this Burnside-line car lays over on Church Street, East Hartford, in 1936, waiting for his next trip.

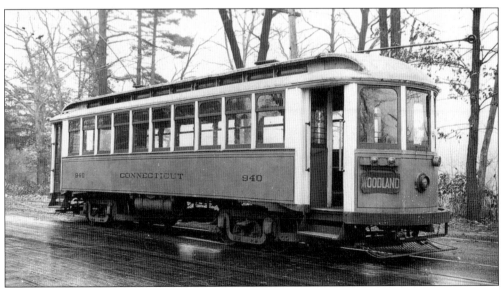

A layover occurs for Car No. 940 at Woodland Switch near Burnside Avenue and Long Hill Road in East Hartford. This was a turn-back point for some of the cars that came from Hartford; every other car continued to Manchester.

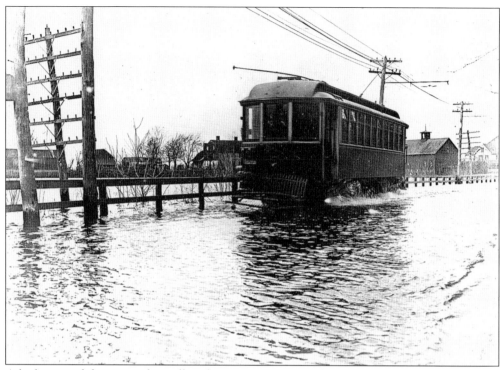

A little water did not stop the trolleys from running, as seen here with Glastonbury-bound No. 1309 wading through the spring flood on Main Street, East Hartford, in 1924.

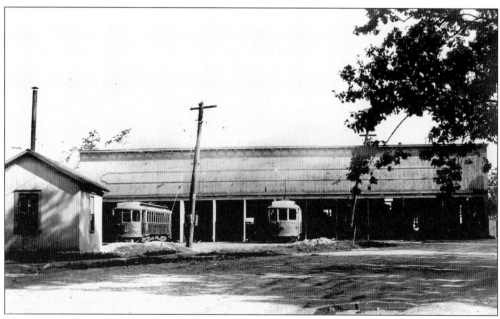

The Manchester car barn is seen here in 1921. Car barns were located at various places throughout the Hartford area. The Connecticut Company had eight car barns in the Hartford Division. This building burned in 1921 and is now the site of the Manchester Town Hall and Fire Station One.

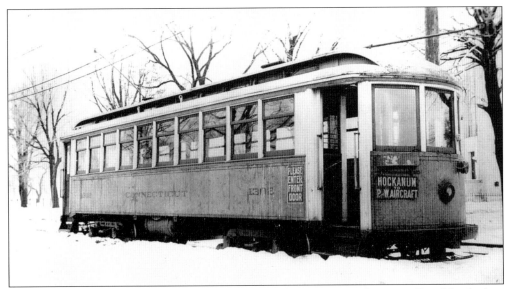

Extra trips ran to the Pratt & Whitney Aircraft plant on Main Street in East Hartford to transport workers at the change of shift, as shown in this 1934 view. This was the location of Willow Brook Switch and the freight siding into the Pratt & Whitney facility, which is currently situated on the corner of Main and Ensign Streets.

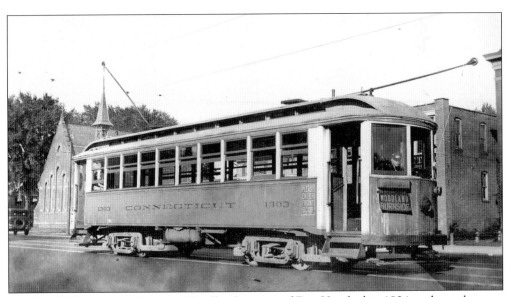

Car No. 1303, inbound from the Woodland section of East Hartford in 1934, is shown here on Main Street, East Hartford, with St. John's Church in the background.

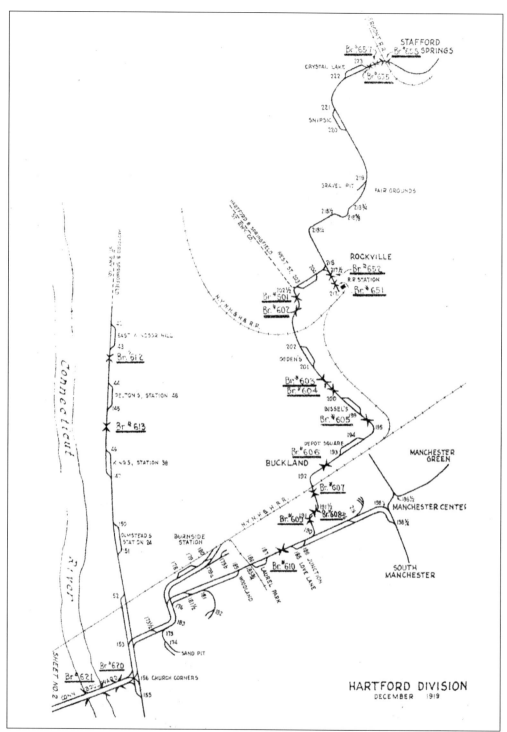

This track map shows the East Hartford, North End, Manchester, and Rockville lines.

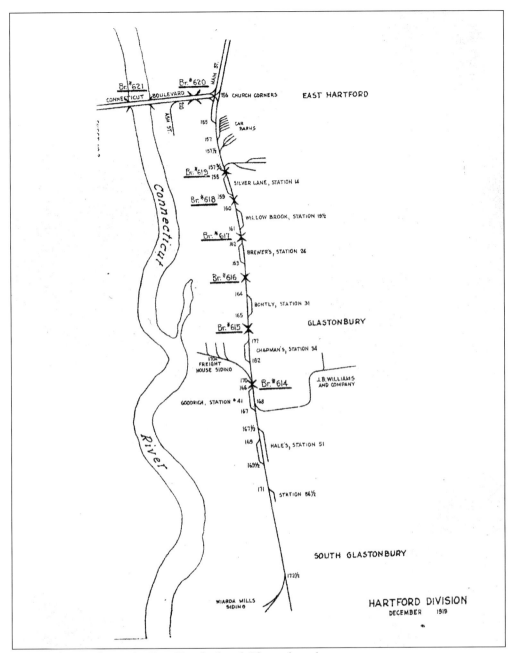

This track map shows the East Hartford and Glastonbury lines.

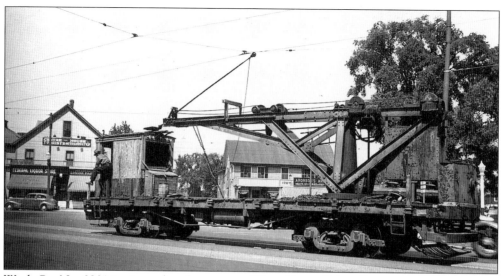

Work Car No. 0201 is pictured at the corner of Burnside and Main Streets in 1935.

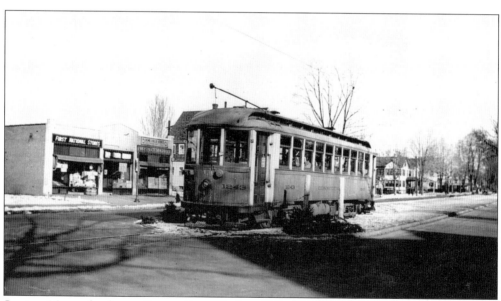

Station 16, on the former line to East Windsor Hill, was located at the corner of Main and Prospect Streets, just north of the New Haven Railroad underpass. The buildings on the left still stand in 2004. This photograph was taken in November 1933 after the line to East Windsor Hill had been cut back to here in February 1933.

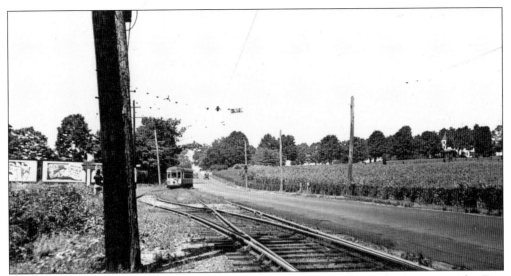

Car No. 1931 approaches Laurel Switch, a passing siding, on Burnside Avenue at the East Hartford–Manchester town line, traveling eastbound to South Manchester. Wickham Park appears in the right background.

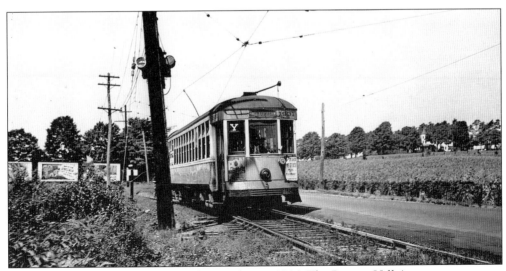

This additional view of Laurel Switch was taken in 1936. The Beacon Hill Apartments are now located here on Burnside Avenue.

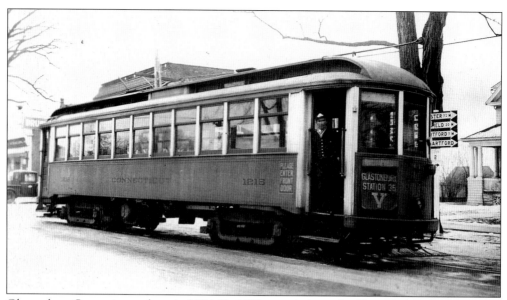

Glastonbury Center is seen here in 1934. By 1935, streetcar runs had been reduced to a few trips each morning and afternoon, with buses providing the bulk of the service. By September 1938, streetcar service had ended, following the destruction of the overhead wire system by a hurricane. The streets were lined with many large elm trees uprooted by the storm. After the hurricane, freight service remained until it, too, was discontinued in September 1958 with the closing of the J. B. Williams plant.

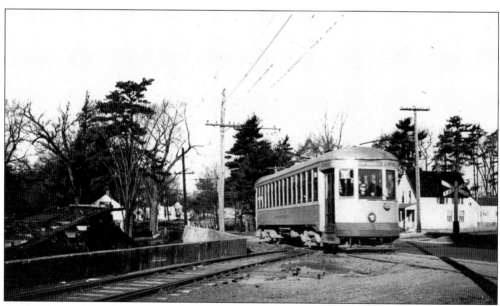

A Manchester-bound car crosses the private siding for the Case Brothers Paper Company mill in the Woodland section of East Hartford. The mill had its own three-quarter-mile railroad line, which connected with the New Haven Railroad but not with the trolley line.

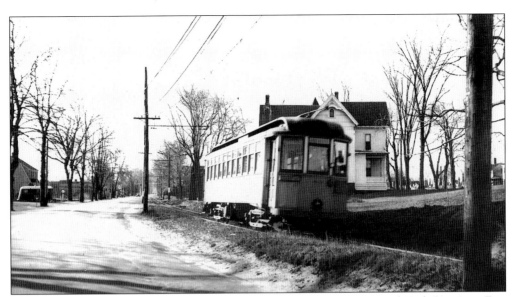

Car No. 1213 is bound for Hartford on the Glastonbury line near Main and High Streets in East Hartford. By 1937, when this picture was taken, only rush-hour service was operating to Glastonbury Center. After the hurricane of 1938, this line saw only freight service. The line was cut back to this point in 1958, when the last freight customer in Glastonbury closed.

If one were to look out through the operator's window of Car No. 1213 (see top image), this is what one would see. The Pratt & Whitney Aircraft plant appears faintly on the right.

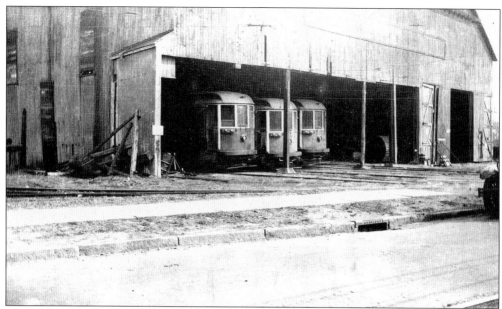

This East Hartford car barn, shown here in 1932, was built by the East Hartford and Glastonbury Horse Railroad in 1892 and was removed in the late 1930s. Currently, the East Hartford Town Hall is located here.

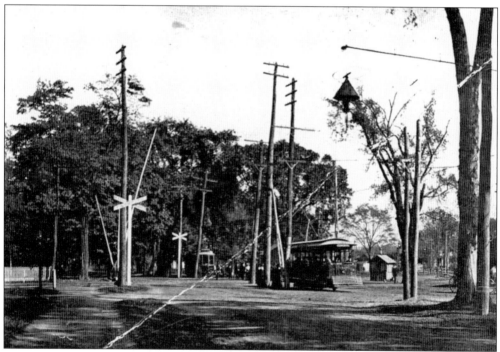

This postcard view shows the New Haven Railroad grade crossing in the north end of East Hartford. Several places in Connecticut had streetcar lines that ran up to railroad lines, but because of safety concerns, streetcars were not allowed to cross the railroad line. People had to get off the car from Hartford and walk across to the waiting East Windsor Hill car. This situation existed until a bridge was built over Main Street in 1905.

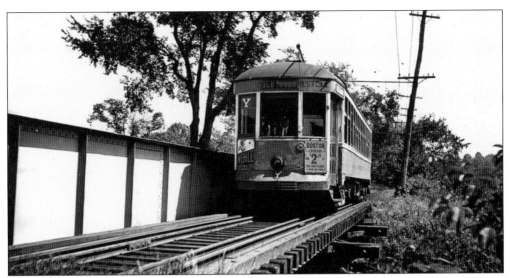

This Hartford-bound car on the Manchester line crosses the Hockanum River in 1938.

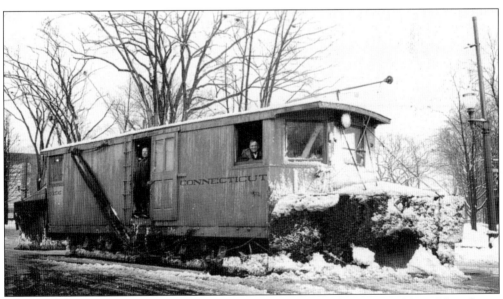

Work cars were needed for many jobs, as shown by this snow plow, No. 0156, on Main Street near Central Avenue in East Hartford in 1934.

In this March 1936 view, the siding that went into the J. B. Williams plant in Glastonbury is seen in the left background. This line never had regular passenger service; it was used for carload freight deliveries to the plant. The overhead trolley wire came down in the 1938 hurricane. Afterwards, the line continued to operate with express cars that had been converted into diesel electric locomotives. The plant closed in 1958, when the J. B. Williams Company moved to Kansas City, Missouri.

Connecticut Company No. 1931 crosses the Buckeley Bridge on November 4, 1939, the last day of streetcar service to Manchester.

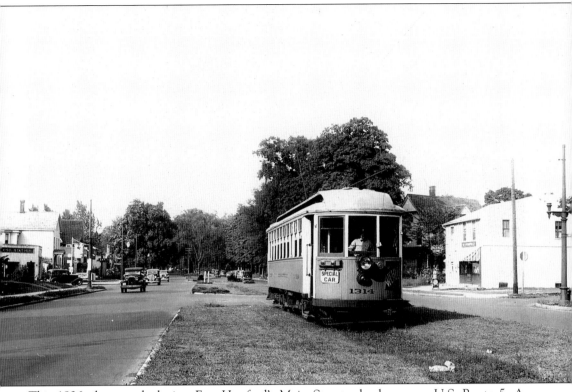

This 1936 photograph depicts East Hartford's Main Street, also known as U.S. Route 5. A streetcar running in the median eliminated many of the safety concerns associated with the cars operating in the street with automobiles.

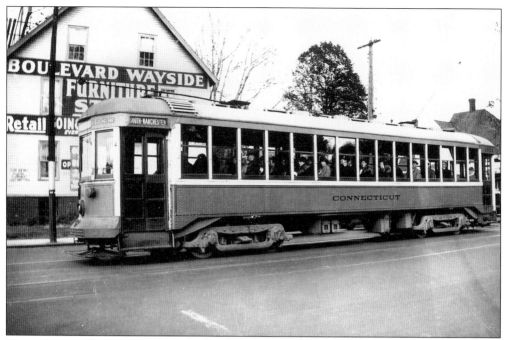

Shown here at Connecticut Boulevard and Prospect Street, East Hartford, is Car No. 1933 on October 30, 1933.

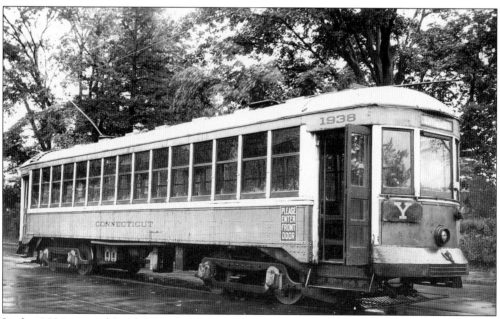

In this 1934 view of South Manchester, Car No. 1931 is at the end of the line at Main Street and Charter Oak Avenue.

Five
ROCKVILLE LINES

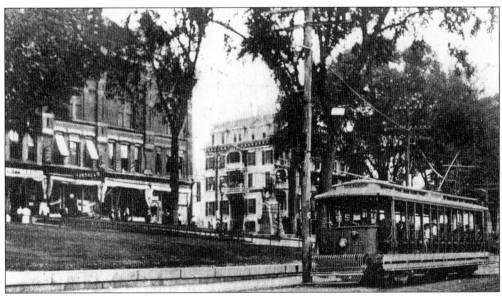

The Hartford-bound Open Car No. 359 runs through Rockville *c.* 1917.

Entering Rockville from Stafford Springs, this car will run down Market Street to the railroad yard and then return to East Hartford on tracks shared with the New Haven Railroad from Vernon to Burnside. This was called the Rockville Interurban. A second line ran via the street through Manchester's Depot Square (the present Route 83) to Rockville. Passengers going to Hartford changed cars at Church Corners, East Hartford, since the interurban cars could not run on the street tracks into the city.

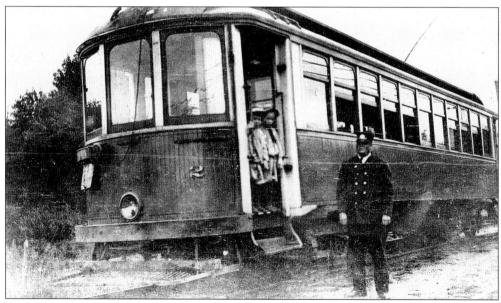

The Wason Manufacturing Company built five cars for the Consolidated Railway in 1906, numbered 1–5, for use on the New Haven Railroad line from Burnside Junction in East Hartford to Rockville via Vernon Junction. This line ran from 1908 to 1924. In 1915, the cars were renumbered 947 to 951. The pictured car was destroyed in a fire at the Rockville car barn in 1918.

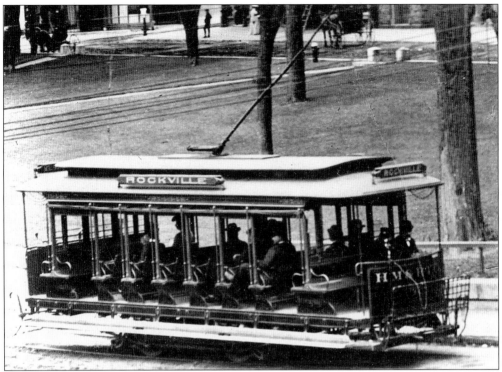

This Hartford, Manchester, & Rockville Tramway car runs in Rockville *c*. 1896. The company owned 16 single-truck open cars, which were purchased between 1895 and 1899. All single-truck open cars were later operated by the Connecticut Company. By 1916, almost all of these types of cars had been scrapped.

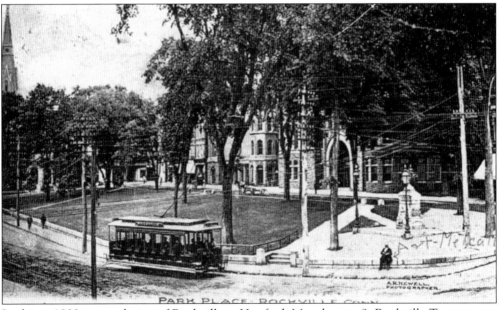

In this *c*. 1900 postcard view of Rockville, a Hartford, Manchester, & Rockville Tramway car appears in the foreground.

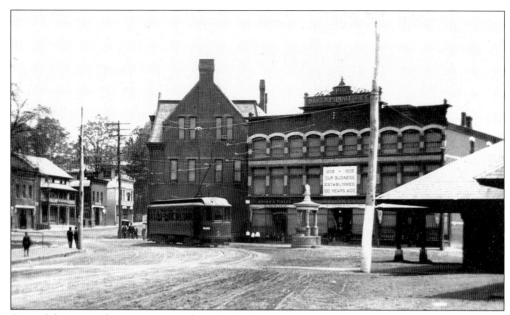

One of the interurban cars assigned to the Stafford Springs run passes through Stafford Springs *c.* 1910. The tracks continued a short distance to the left, where the express cars unloaded their cargo. Cars that came into Rockville from East Hartford on the interurban line continued to Stafford Springs. When the interurban was abandoned in 1924, the cars came up the city line through Manchester and Talcottville.

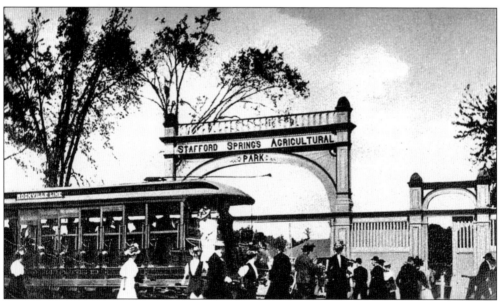

A Consolidated Railway open car is pictured at the Stafford Springs fairgrounds *c.* 1909.

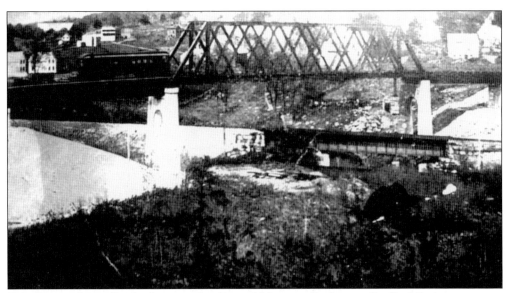

Seen here is the trolley bridge over the Central Vermont Railway at Stafford Springs.

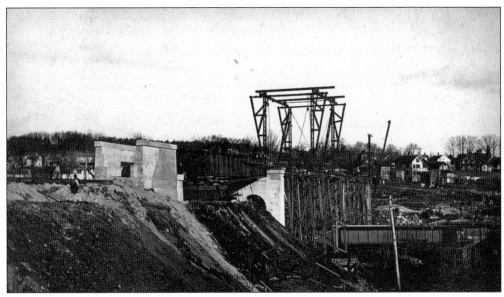

Construction of the trolley bridge over the Central Vermont Railway takes place in 1908.

Express Car No. 2018 lays over in the Rockville freight yard *c.* 1920.

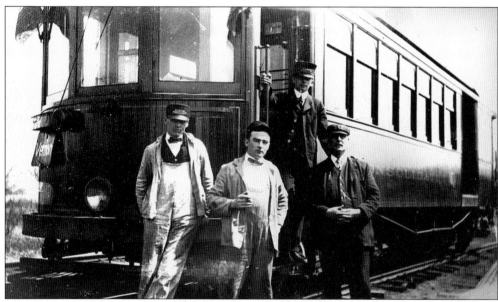

Consolidated Railway No. 7, when operating as a combination car carrying both passengers and freight, needed a four-man crew: motorman, conductor, brakeman, and baggage man. Cars No. 6 and No. 7 ran between Vernon Junction—where they met all Boston and Hartford trains—and Rockville. They also made trips to Melrose from 1908 to 1914. These cars, painted dark green, accepted only railroad tickets, whereas the yellow Connecticut Company cars accepted only cash fares. Built to streetcar standards, Cars No. 6 and No. 7 were modified by the New Haven Railroad to railroad standards, which mostly involved raising the body to railroad coach height and changing the wheels.

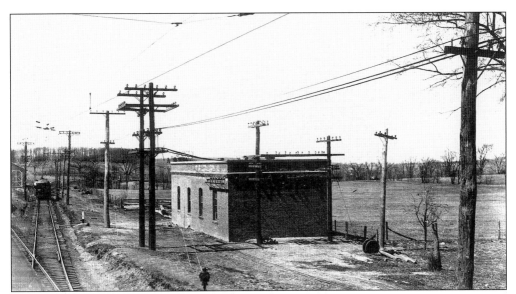

The West Street substation building in Rockville, seen here, still stands today. It had a rotary converter that changed 11,000 volts AC to 600 volts DC. Another substation from the streetcar days was located in the Buckland section of Manchester. It also remains today.

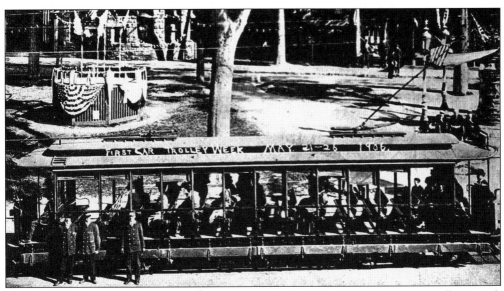

This 1906 photograph shows an open car on the Rockville Green during Trolley Week festivities. New England once had many mill towns that took advantage of the substantial water power available in the region. Rockville is a good example of a small industrial city in the era of the textile mill.

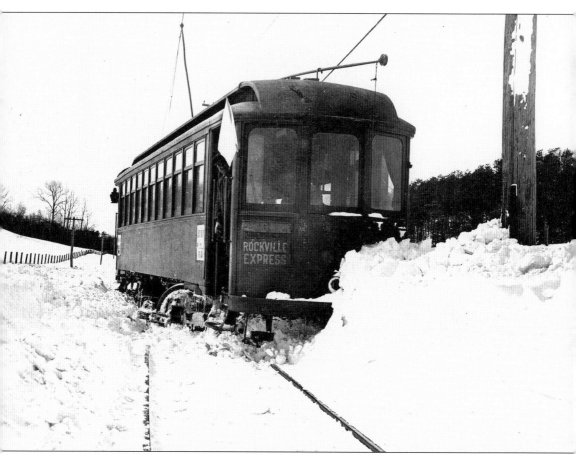

Traveling in snow was sometimes hazardous to streetcars, as evidenced by Rockville Interurban Car No. 950, which derailed after hitting a snow drift on March 17, 1920. Today, Interstate 84 passes over this location.

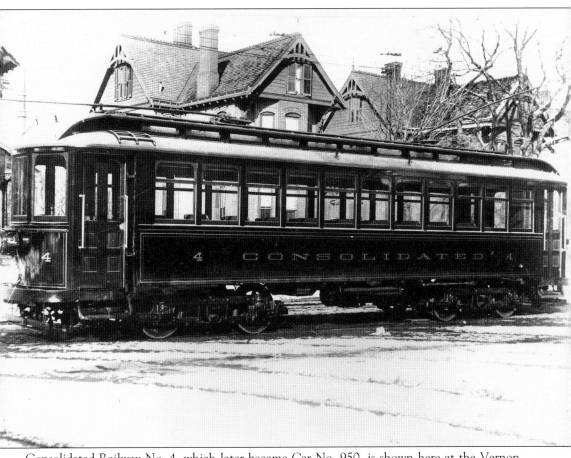

Consolidated Railway No. 4, which later became Car No. 950, is shown here at the Vernon Street shops. The Rockville Interurban line was a Connecticut Company operation that used New Haven Railroad tracks, sharing them with mainline steam trains between Burnside Junction, in East Hartford, and Vernon Junction. Cars operated under the same rules as the railroad. Each car was required to operate as if it were a train with the appropriate markings. A New Haven employee rode along with the trolley crew to act as a "pilot" while on the New Haven tracks.

A Rockville Interurban car runs at speed on the single-track line between West Street in Rockville and Vernon Junction. In good weather, these cars could reach speeds of 50 miles per hour.

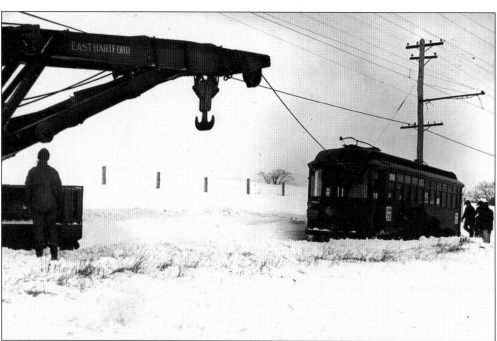

In this March 17, 1920 scene, the New Haven Railroad crane from East Hartford helps No. 950 get back on the track after the car ran into a snow bank and derailed.

Six
NEW BRITAIN LINES

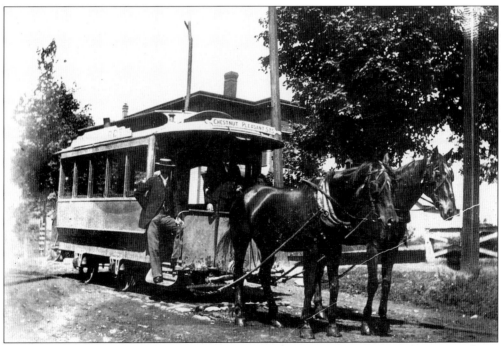

Small one-truck cars—like the horse car in this 1890 scene—ran on New Britain Tramway lines.

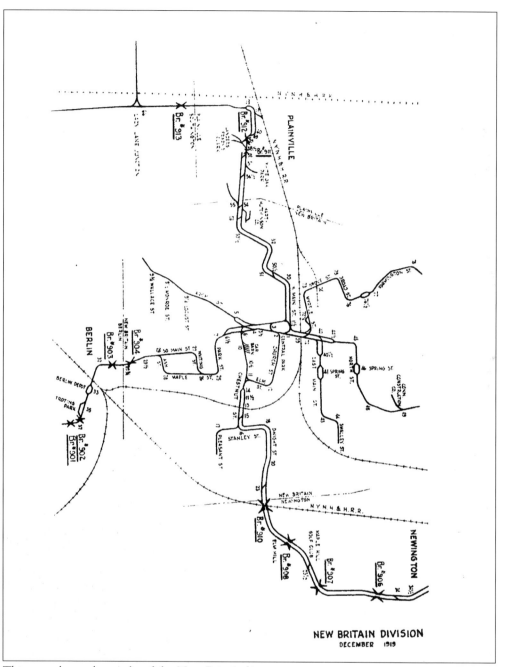

This map shows the tracks of the New Britain line.

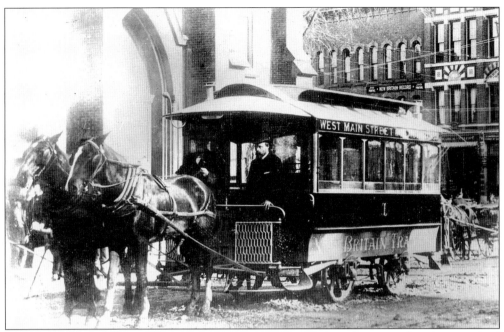

West Main Street in New Britain was not yet paved in 1890, as shown in this photograph of New Britain Tramway No. 8.

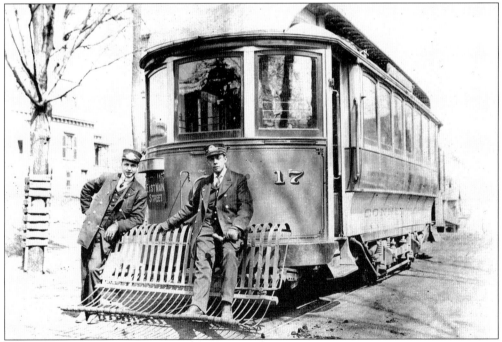

After the electrification of the New Britain Tramway in 1893—thus doing away with the need for horses—the company became the Central Railway & Electric Company. In 1901, the name was changed again, creating the Connecticut Railway & Lighting Company. This company purchased Car No. 17 from Wason Manufacturing in 1906. The Connecticut Company leased the Connecticut Railway & Lighting Company on August 1, 1906, and renumbered this car 882.

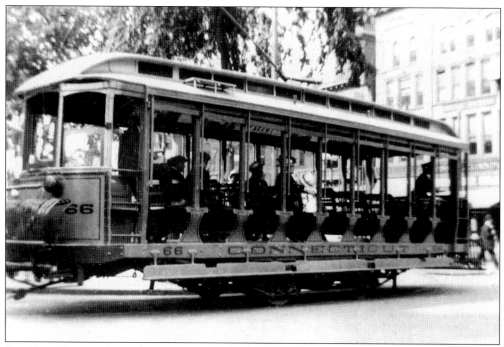

Car No. 66, a single-truck open car, was built by the J. G. Brill Company of Philadelphia, Pennsylvania, in 1895 for a predecessor of the Connecticut Company. It was scrapped in 1916.

New Britain Car No. 403 was built by the J. G. Brill Company in 1897. These cars were expensive to run; they were built out of wood, and parts were starting to deteriorate in the early 1900s due to overuse. By 1920, they had become obsolete.

The trolley car was becoming an unusual site in downtown New Britain by May 1936. All the New Britain city lines had been converted to bus by 1932; only the lines to Hartford and Plainville continued to have trolley-car service.

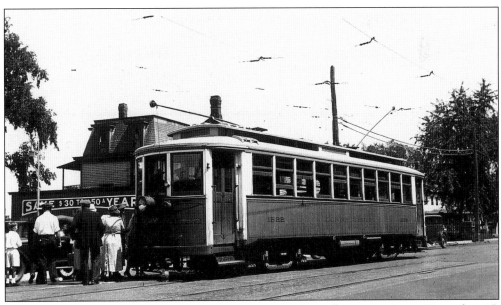

Car No. 1522 loads passengers on East Main Street, Plainville, in 1935. On November 15, 1936, this line was converted to a bus operation.

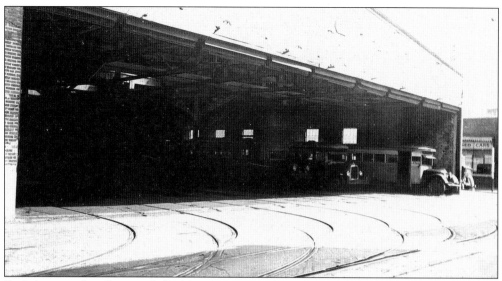

Both buses and trolleys used the New Britain car barn for servicing, seen in this May 1936 photograph. The building continued to be used for buses until the 1970s.

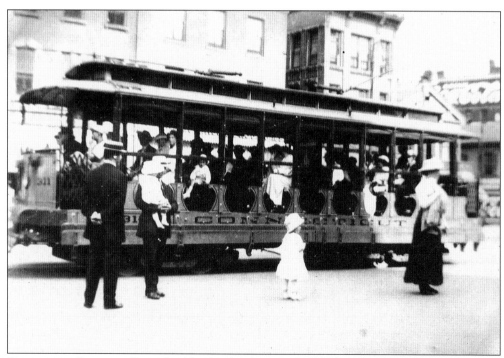

Connecticut Company Open Car No. 311 loads passengers in downtown New Britain c. 1920. This car was built in 1905 by the Cincinnati Car Company for local New Britain runs.

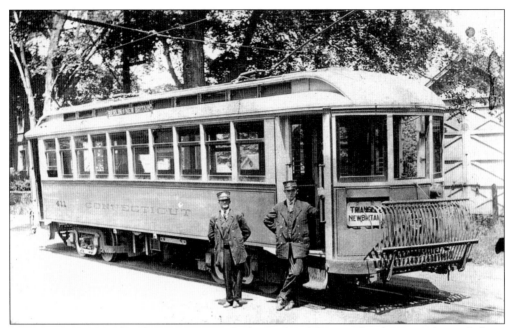

Car No. 411, assigned to the New Britain–Berlin Railroad Station shuttle, sits in front of a barn in Berlin in this 1914 photograph. This car was built in 1910 by the Osgood Bradley Car Company of Worcester, Massachusetts.

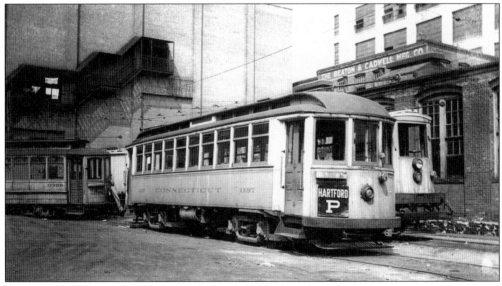

Just in from Hartford, Car No. 1197 lays over at the New Britain car barn.

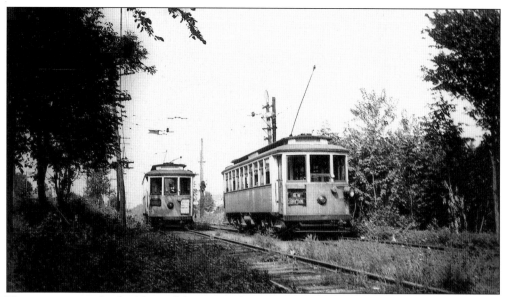

Two cars pass on the double track between Plainville and New Britain. The car bound for New Britain appears on the right side and the Plainville car on the left side of this photograph. The future route of Interstate 84 is to the left of the Plainville-bound car.

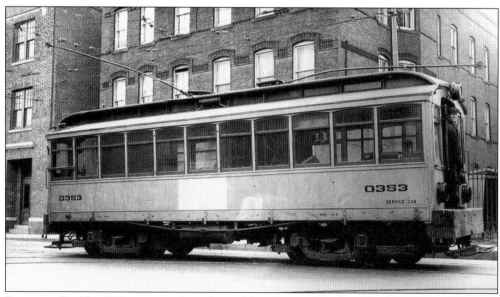

Passenger Car No. 876 was reconfigured into New Britain Wrecker No. 0353. This impressive piece of equipment responded to all derailments. It was outfitted with tools and could carry the manpower needed to put cars back on the track, thereby preventing unnecessary delays in service.

Passenger Car No. 1830 approaches the switch to the Edward Balf Company quarry in Newington. This line was opened in 1895 and was converted to bus in 1937.

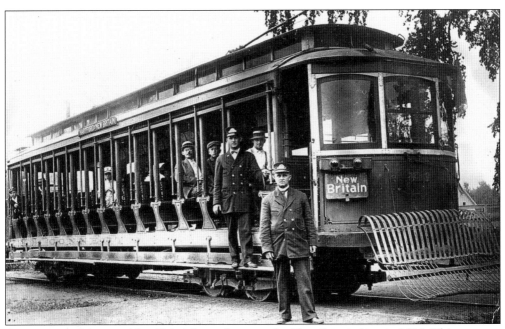

Connecticut Company No. 304 is shown here on the New Britain line in 1910. This was one of a series of eight cars built in 1897 by the J. G. Brill Company. Originally built for Hartford to New Britain service, four were sold to the New Haven Railroad in 1898 for use on the newly electrified line between Hartford and Bristol. The New Haven used a third rail between the tracks to power the cars, thus eliminating the need for overhead wire.

A New Britain–bound car crosses Ellsworth Street, Newington, in March 1937. Service from Hartford to New Britain ended on April 27, 1937. On November 16, 1936, operations of all the former Connecticut Railway & Lighting Company lines under lease to the Connecticut Company, including the New Britain line, were returned to the Connecticut Railway & Lighting Company since the Connecticut Company could no longer afford to make the payments.

The Connecticut Company turned over a number of cars to the new Connecticut Railway & Lighting operation, enabling the operation to continue service with streetcars until enough motor coaches could be purchased to end streetcar operations. One of these cars was No. 1830, shown here on the Hartford to New Britain line in the area that paralleled Newington Avenue.

Seven
NORTH TO WINDSOR

Car No. 950 prepares to leave Windsor Center in this August 25, 1934, scene. No. 950 formerly ran on the Rockville Interurban line.

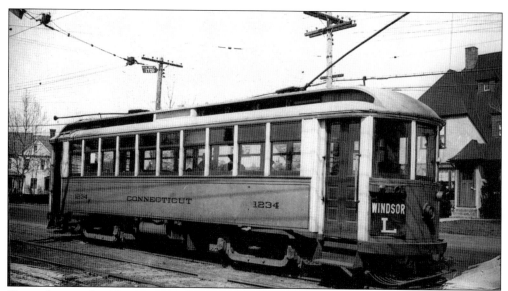

Shown here is Car No. 1234 on the Windsor line in 1938. By 1940, all service was provided by buses.

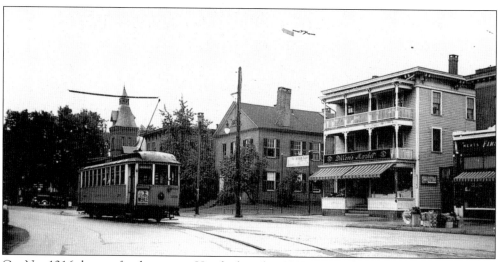

Car No. 1216 departs for downtown Hartford in this 1937 view. The tracks in the foreground are those of the Hartford & Springfield Street Railway, abandoned in 1926. The Hartford & Springfield ran on both sides of the Connecticut River using trackage rights to enter both cities.

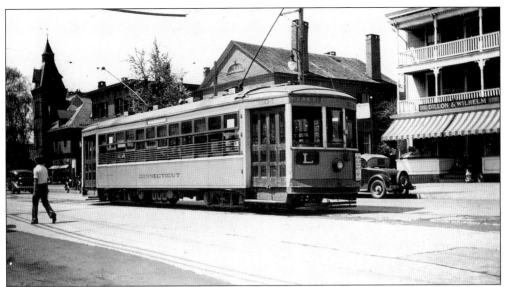

Car No. 1936 changes ends in Windsor Center. Streetcars continued to run to Windsor until being cut back to the Hartford city line in 1940.

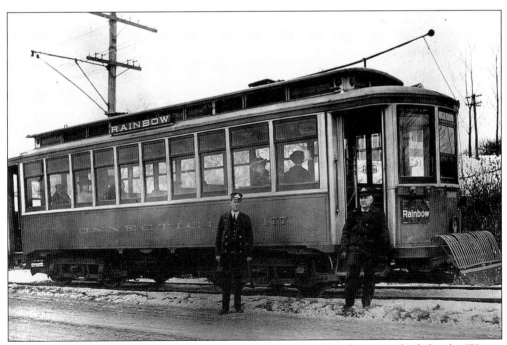

Car No. 477, shown here on the Windsor line en route to Rainbow, was built by the Wason Manufacturing Company of Springfield in 1905 for the Consolidated Railway. This car became No. 846 in the 1915 renumbering.

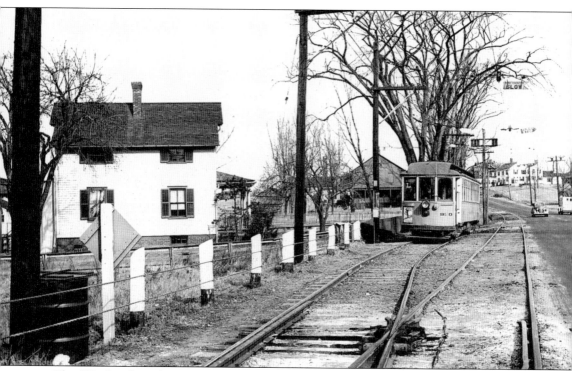

This Windsor-bound car comes into Decker's Siding on Deerfield Avenue.

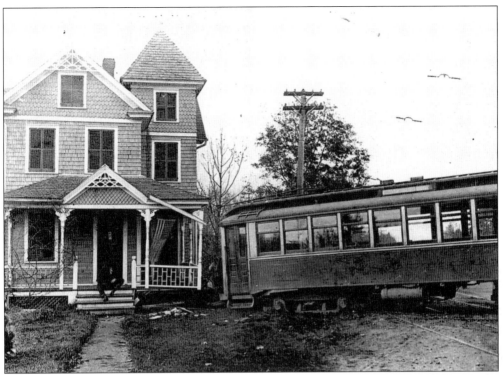

The operator of Car No. 1235 awaits assistance. The location is not marked here; however, the photograph was most likely taken on the Windsor line.

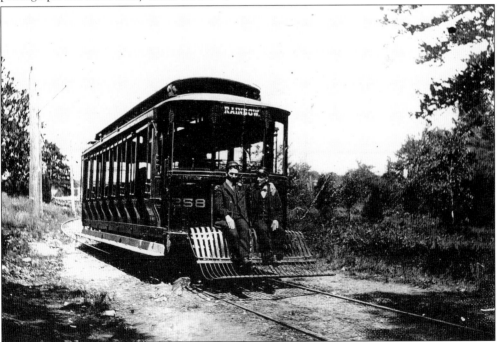

The crew of Hartford Street Railway No. 258 sits at the end of the Rainbow line in Windsor in 1905.

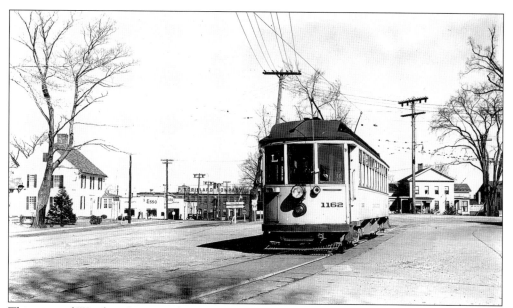

This view of Windsor Center, taken on April 7, 1940, still shows very few automobiles.

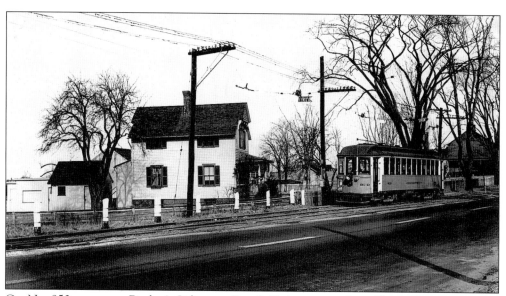

Car No. 950 appears at Decker's Siding on Deerfield Avenue in this additional view.

Eight
WEST TO UNIONVILLE

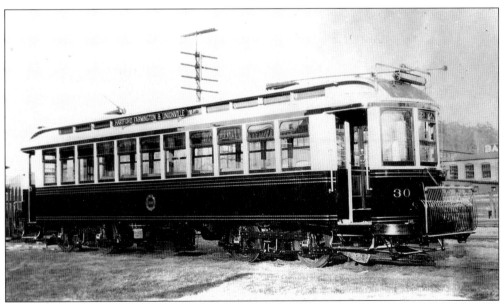

Farmington Street Railway No. 30 was built by Wason Manufacturing in 1907. After the Farmington Street Railway was purchased in 1910, the car became Connecticut Company No. 1163. The Farmington Street Railway ran to downtown Hartford on trackage rights from West Hartford Center.

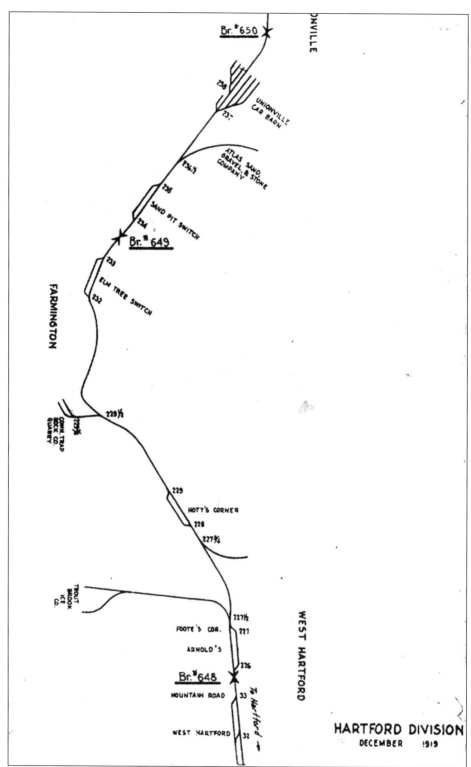

This map shows the tracks of the Unionville line.

112

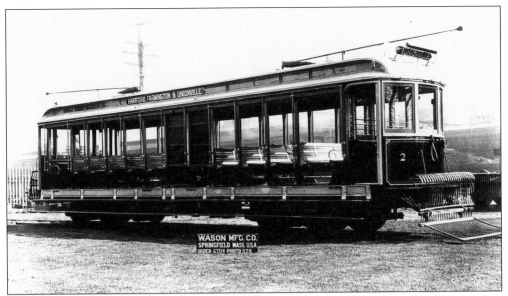

Builder's photographs, like this one of Farmington Street Railway Open Car No. 2, were taken by the manufacturer prior to delivery of the car to the line. This photograph was taken in 1908 by the Wason Manufacturing Company. This car later became Connecticut Company No. 1244. Farmington Street Railway cars were painted Tuscan red.

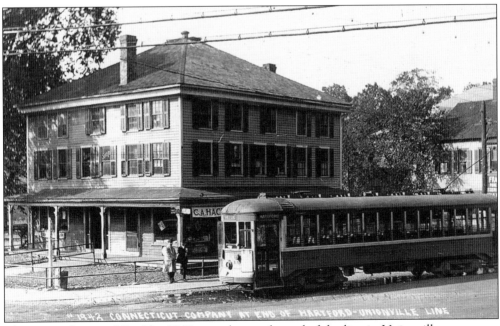

This postcard view of Car No. 1942 was taken at the end of the line in Unionville.

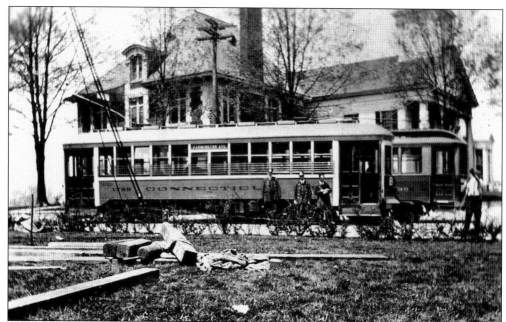

In this *c.* 1924 view of West Hartford Center, note the man on the right taking a photograph of the crew of No. 1722. The third man is most likely a supervisor.

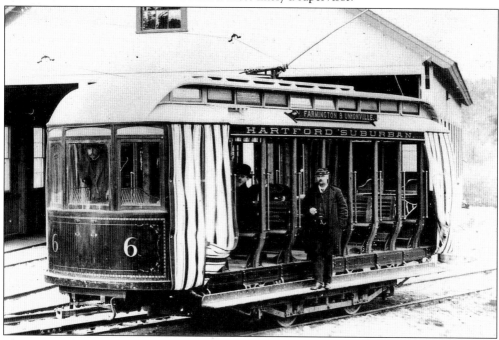

The Hartford Suburban Street Railway was owned by the Farmington Street Railway in a complicated legal arrangement because it did not own any trackage but operated on the Farmington line. The manufacturer of No. 6, built in 1893, was Jackson & Sharpe of Wilmington, Delaware. This car was one of six ordered by the Hartford Suburban Street Railway. By 1900, it was off the list of equipment and never appeared on the Connecticut Company equipment list. There is no record of what happened to these cars.

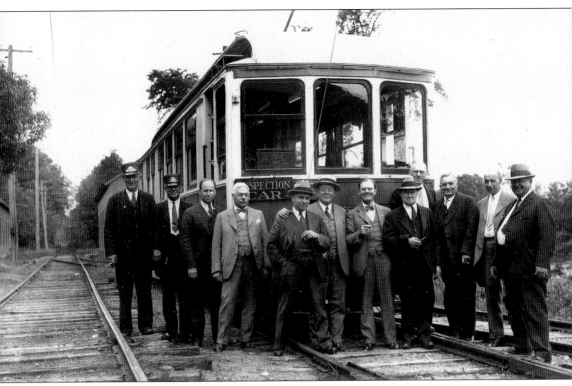

This June 11, 1931, inspection trip on the Unionville line by the Public Utilities Commission used Connecticut Company Parlor Car No. 500. The photograph was taken at the Unionville car barns. Car No. 500 survives today at the Shore Line Trolley Museum in East Haven.

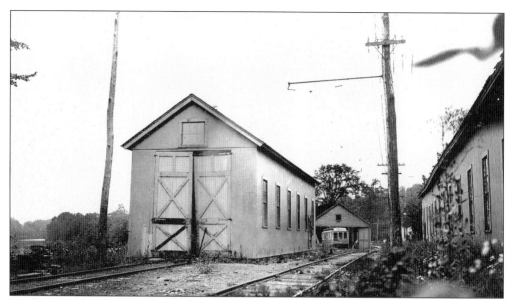

The Unionville car barns, shown here in July 1921, were of a different design than the ones previously shown. Note Parlor Car No. 500 in the background. This car must have been in Unionville on a Public Utilities Commission inspection trip; No. 500 was normally kept in New Haven.

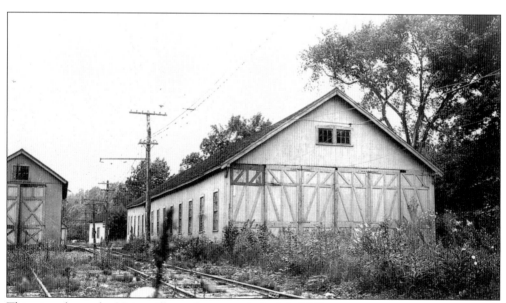

This view shows the Unionville car barns, again in July 1921.

Trolley cars run along Route 6 in Farmington Center in 1933. On June 4, 1933, streetcar service ended on the Unionville line. Bus operation began the next day.

In this 1930s view of the Unionville line, the New Haven Railroad's line to Holyoke is seen in the foreground. Even though it was loosing money in the 1930s, the Connecticut Company maintained the tracks and cars in good condition right up until the lines closed.

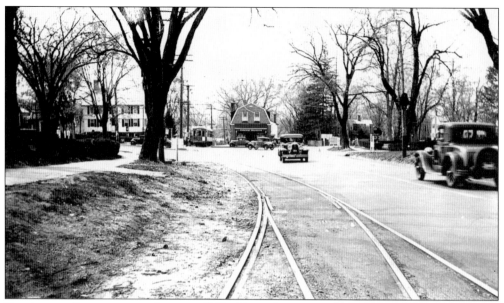

Farmington Center is seen here in 1933. Note the streetcar signal on the pole near the automobile on the right. This provided protection for trolley cars running on the single track between Elm Tree Switch, shown here, and the next siding at Nott's Corner.

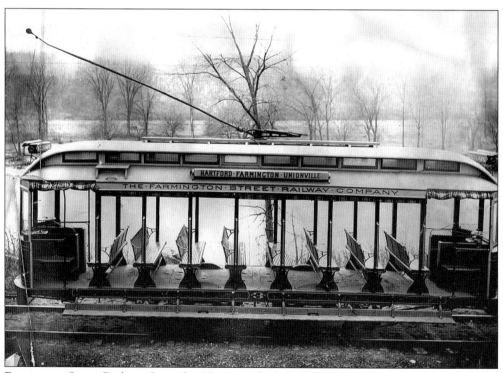

Farmington Street Railway Open Car No. 3 was built by Jackson & Sharpe in 1895. It became Connecticut Company No. 258 and was most likely scrapped in 1916, along with many of the single-truck open cars the company had inherited.

Nine
TROLLEY FREIGHT

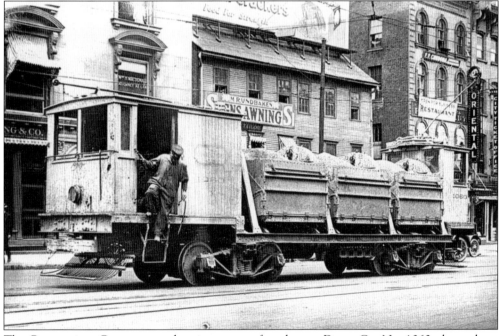

The Connecticut Company used various types of work cars. Dump Car No. 1060, shown here on Main Street and Central Row in Hartford, is en route to deliver crushed stone from the Edward Balf Company quarry in Newington. Freight deliveries, including crushed stone, were a major source of revenue for the company.

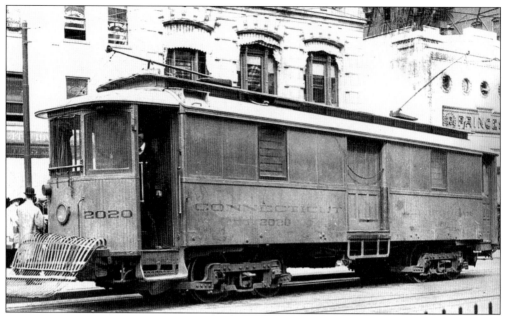

Express Car No. 2020—originally Farmington Street Railway No. 26 and shown here on State Street in Hartford—was built from two single-truck cars before 1900. In 1908, the Wason Manufacturing Company rebuilt it into an express car. These cars operated mostly at night and provided overnight package delivery to points in Connecticut, Massachusetts, and New York City. This was the predecessor to services now provided by the United Parcel Service and FedEx.

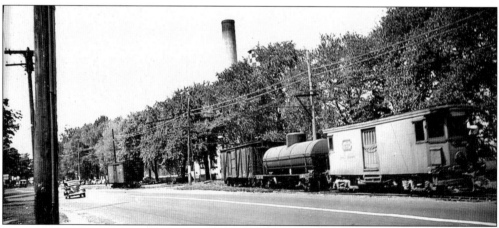

The Pratt & Whitney Aircraft Corporation moved its engine manufacturing plant from Capital Avenue in Hartford to East Hartford in 1929. One of the reasons the company picked the site in East Hartford was that the trolley line ran past the site. In fact, freight service was already being provided to the plant of the J. B. Williams Company in Glastonbury, a prominent producer of toiletries. Express Car No. 2023, shown in this 1934 scene, switches to the Pratt & Whitney plant. Also located at the factory complex was a plant of the Chance Vought Corporation. Both companies were divisions of the United Aircraft & Transport Corporation. The plants contained more than one mile of track. The smokestack seen in the photograph was for the powerhouse, which provided steam and electricity for all the buildings. It was fueled by coal delivered by the trolley line.

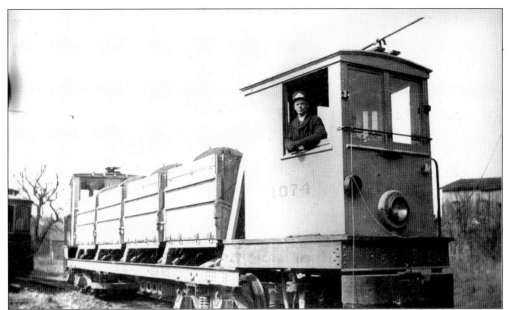

Motorman Clarence Simpson appears in the cab of Dump Car No. 1070 in this 1914 photograph.

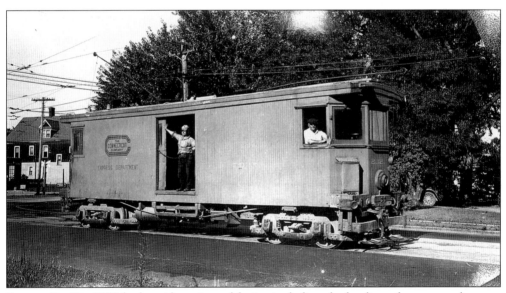

Express Car No. 2023 had a wide variety of duties, including the hauling of express packages at night and freight on the Glastonbury line during the day. The Connecticut Company had extensive freight business on the Hartford Division since the local cities and towns did not object to freight trains running in the streets. Many cities like Philadelphia, Baltimore, Pittsburgh, and St. Louis required streetcar lines be built in a different gauge to prevent the handling of freight cars by the operating streetcar companies. All the streetcar lines in Connecticut were built in standard gauge, which meant that freight cars could be exchanged with the mainline railroads.

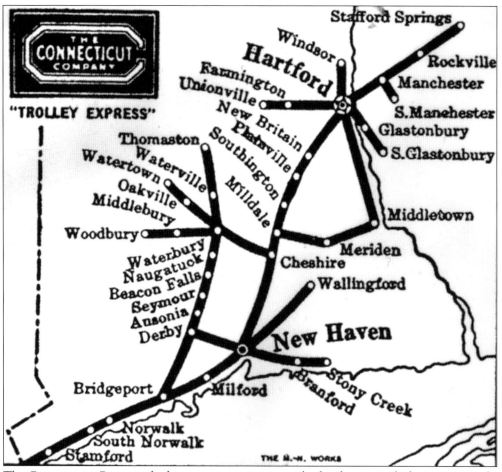

The Connecticut Company had a very extensive overnight freight service before motor trucks took most of the business in the early 1930s. This map shows the network in place in 1919. In 1908, the Connecticut Company formed the Express Department to sell and oversee the company's package and freight services. The longest run was the nightly Hartford to Bridgeport route through New Britain, Plainville, Cheshire, and New Haven. Cars also ran to Waterbury and other points to interchange with systems in Massachusetts, Rhode Island, and New York. Express cars, such as No. 2022 and No. 2023, usually hauled one or more trailers on these runs. The company had a total of 58 freight terminals in Connecticut alone!

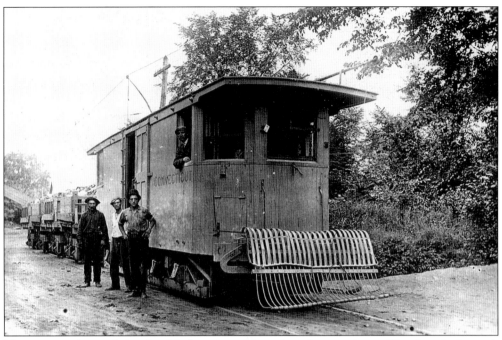

Here, a snowplow with its plow blades removed is used as a locomotive, pulling four single-truck cars filled with crushed stone out of the Edward Balf Company quarry in Newington. A Hartford city ordinance did not allow the Connecticut Company to operate a plow with its blades on except during the winter season. What these cars are headed for is the Edward Balf plant on Huyshope Avenue in Hartford. The cars were called dump cars because they dumped their load by raising one side in a manner similar to a dump truck.

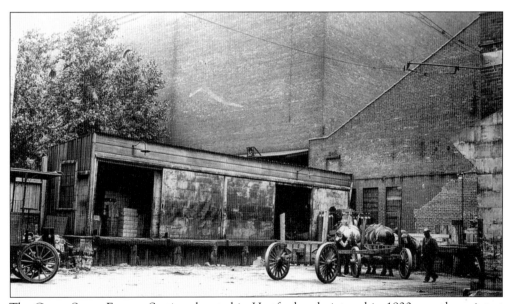

The Grove Street Express Station, located in Hartford and pictured in 1920, was the point at which packages were transferred to the teams of horses and wagons used for local deliveries. Motor trucks were also used; note the early electric truck on the left.

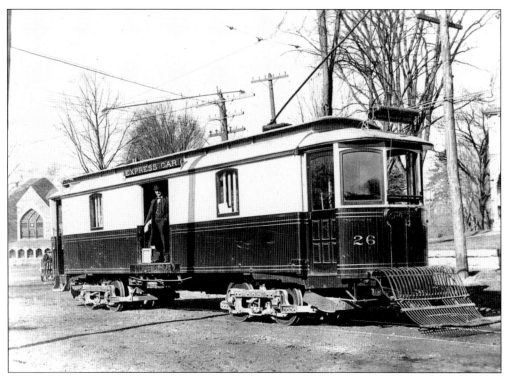

Express Car No. 26 runs on the Farmington Street Railway. It later became No. 2020, as shown on page 120.

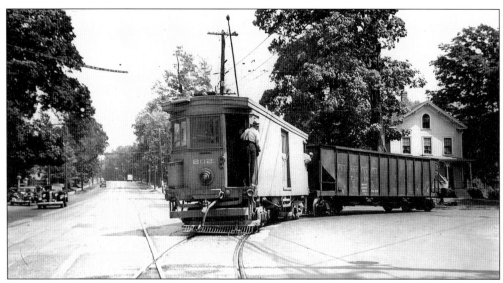

Express Car No. 2023 pushes a hopper car of coal down Church Street in East Hartford to the Taylor and Atkins Company, located at the end of the quarter-mile street. Burnside Avenue is still relatively free of traffic in this 1937 scene.

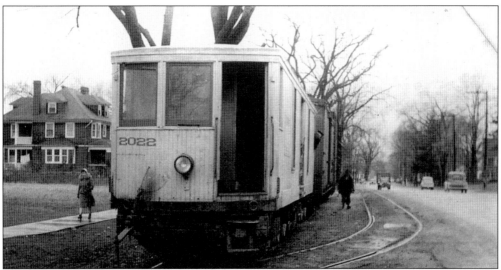

Express Car No. 2022 switches the small freight yard, located where St. Paul's Church stands today, in this 1946 scene of Glastonbury Center. No. 2022 was a 1911 product of the Wason Manufacturing Company. When the 1938 hurricane destroyed most of the overhead trolley wire on the Glastonbury line, the company chose not to replace it and instead converted No. 2022 to a gasoline electric locomotive. The freight sidings here had a number of customers, including the Pequot Soda Company, Dickau Lumber, and the Herman Rossier Tannery. The operators on this line told stories about the carloads of hides delivered to the tannery. It was said that one could smell the car long before actually seeing it. Once a boxcar was used to transport hides, it could no longer be used for any other freight. No. 2022 was donated to the Connecticut Trolley Museum in 1966, where it can still be seen today.

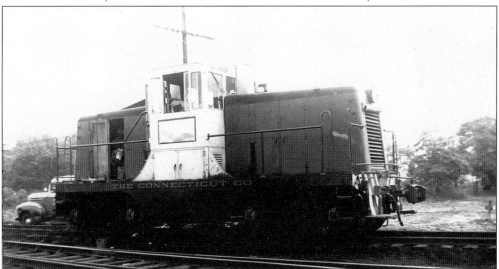

In 1957, No. 2022 and No. 2023 were replaced by this former New Haven Railroad diesel locomotive. This was the last piece of rail equipment acquired by the Connecticut Company. No. 0809 was a 380 HP General Electric 44-ton diesel electric locomotive. It ran until 1965, when it was replaced by a similar unit, No. 0812, rented from the New Haven Railroad. No. 2022 was kept for snow removal service. No. 2023 was donated to the Connecticut Trolley Museum, where it still operates today.

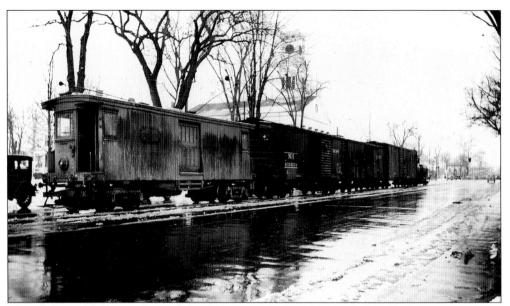

This photograph shows a four-car freight train on Main Street, East Hartford, in 1930.

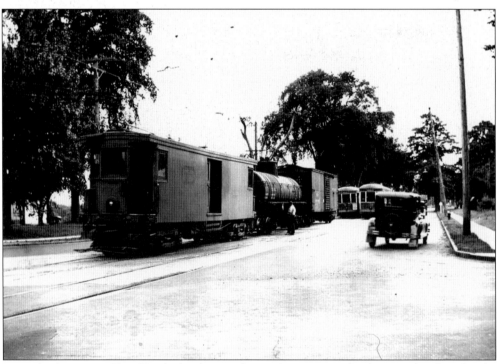

Burnside Avenue in East Hartford is busy today, with a two-car freight train heading for the Burnside yard and a Manchester-bound car following. The second passenger car is inbound to the Isle of Safety in Hartford. A switch into the stone quarry operated by the Hartford Sand & Stone Company was at this location until the 1920s. The site later became the East Hartford landfill.

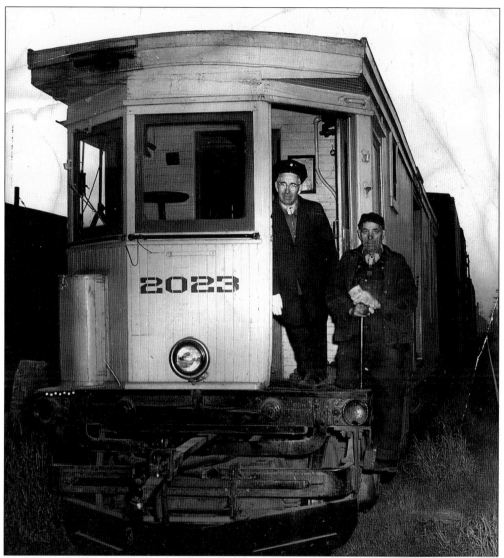

Conductor Ed Barsleu (left) and brakeman Thomas Valente (right) appear in this 1950 photograph taken in Burnside yard in East Hartford. These two gentlemen were the regular operators on the freight line for more than 20 years.

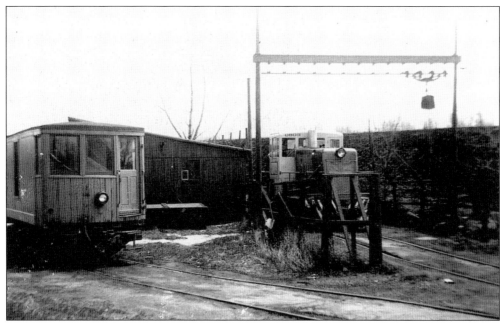

After streetcar service was discontinued in Hartford in July 1941, the equipment for the freight operation was kept in this yard on Main Street in East Hartford. The building in this 1959 photograph was formerly a freight house. The site is next to the East Hartford Fire Department Company No. 1 station and the East Hartford Town Hall, both of which sit on land formerly occupied by the East Hartford car barn. At the time of the photograph, No. 2022 was used mostly for snow removal and as a backup locomotive for the diesel that performed most of the switching. After 1958, Pratt & Whitney Aircraft was the only customer left on the line. The company continued to ship jet engines via rail and receive cars of jet fuel and argon gas for the plant until the last trip was made in November 1967, after Pratt & Whitney had switched their business to trucks. All the tracks were removed from the streets by July of the following year.

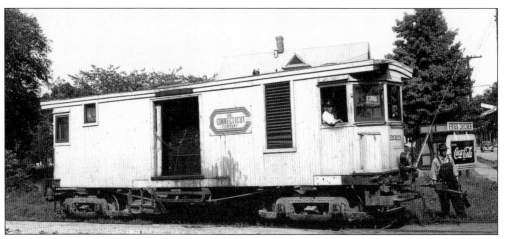

Express Car No. 2023, shown in this 1948 photograph, was converted into a diesel electric locomotive using a secondhand Mack bus engine in 1938. The same electric motors and controllers remain from when the car drew its power from the overhead wire, though they are now powered by the generator, which is of course powered by the new diesel engine.